MW00619864

SOUTH DAKOTA'S
........ *Cowboy Governor*
TOM BERRY

SOUTH DAKOTA'S
········ *Cowboy Governor* ········
TOM BERRY

Leadership During the Depression

PAUL S. HIGBEE

THE
Hiſtory
PRESS

Published by The History Press
Charleston, SC
www.historypress.net

First published 2017

Manufactured in the United States

ISBN 9781467119412

Library of Congress Control Number: 2017934931

Notice: The information in this book is true and complete to the best of our knowledge. It is offered without guarantee on the part of the author or The History Press. The author and The History Press disclaim all liability in connection with the use of this book.

CONTENTS

ACKNOWLEDGEMENTS

Rena Berry, although I never met her, tops the list of people who helped me with this book. She collected her husband Tom's speeches, campaign posters, significant letters and telegrams and more. Rena organized scrapbooks of invaluable news clippings and photos. Other Berry family members who were especially helpful were niece Jan Rasmussen, who invited me into this project; granddaughter Nancy Phipps; and grandson Shorty Jones.

I found great resources and staff who took a true interest in this book at these libraries and museums:

- Center for Western Studies, Augustana University, Sioux Falls
- Civilian Conservation Corps Museum of South Dakota, Hill City
- Homestake Adams Research and Cultural Center, Deadwood
- Leland D. Case Library for Western Historical Studies, Black Hills State University, Spearfish
- Minnilusa Pioneer Museum, Rapid City
- Siouxland Heritage Museums, Sioux Falls
- South Dakota State Historical Society Archives, Pierre

At times, I felt as if I were on a Tom Berry–style campaign, driving through all sections of South Dakota and meeting people who told bits of the story in small-town cafés and bars and over their kitchen tables. Thanks especially to three South Dakotans who have held elected office and offered insights

and directed me to resources I wouldn't otherwise have found: Don Barnett, Bernie Hunhoff and Kay Jorgensen. I especially enjoyed a trip to Gregory County to learn more about Tom Berry's early years in South Dakota. Jim and Marilyn Pochop were my hosts, and John Pochop, Shelly Day and Jack Broome taught me a lot of Gregory County history.

Ryan Phillips hit the road and shot original photography for the book. Karen Laumer, as she has for many of my previous projects, helped me with all things technical, including end-noting, proofreading and overall organization.

Chapter 1
GREAT PLAINS FRONTIER

Young men paced nervously, waiting to compete for saddle bronc honors at a 1922 rodeo in White River, South Dakota. To score well, they knew, they had to spur the bronc so it bucked impressively, keep a firm grip to stay aboard and endure being tossed violently forward and backward.

Three judges sat ready to score the rides. Someone suggested that these judges mount up and ride some bucking broncs themselves. That way competitors and the big crowd could rest assured that the judges knew their business. It was a joke—everyone understood these three were well qualified. The banter was part of the show, and a judge could easily decline the challenge, offering any humorous, self-effacing excuse. Or he could sit atop a bronc but not spur it, a course one man took that day. But not rodeo judge Tom Berry. At forty-three, he was twice the age or more of most riders. Still, he declared himself up to the challenge and started to climb onto an especially spirited horse that bolted and escaped the wranglers, leaving Berry behind. So, he mounted another, spurred it sharply so it bucked mightily and held on for "a good ride."[1]

There are moments in everyone's life that aren't of great significance in the long view of things yet define that individual's core makeup. So it was with Tom Berry that day. He always seemed to find himself in the middle of things, seldom just a spectator and often in a position of authority. He saw humor in situations and might jump into them, but that didn't mean he played a fool. There was humor enough in a forty-three-year-old aboard a bucking bronc without the man making a mockery of the ride. Tom Berry,

friends said, was fearless in the face of challenge, be it bucking livestock, facing rattlers and wolves or negotiating with a skeptical president of the United States at the White House.

A decade after that White River bronc ride, Tom Berry rose to the challenge of leading South Dakota as governor when the state faced the double calamities of the national economic depression and the Great Plains Dust Bowl. The day Berry took office, the state treasury sat drained, big debt obligations were due and citizens expected him to do something about it. Constituents called Berry "the cowboy governor," and nobody considered the image a political gimmick. A cowboy was honestly who he was in manner, speech and, most significantly, outlook and work ethic. Observers noted his cowboy gait as he stepped into the White House and his cowboy expression and manner as he interviewed a candidate for a state position.[2] As for outlook, Berry expected the world to present perennially hard tasks to be met with limited resources. Wasting money or any other resource amounted to sin. Taking on debt was foolish.

And then there was the matter of professional background. As Berry's political career advanced in the 1920s and '30s, he owned the vast Double X ranch, which he built from scratch, an operation claiming thousands of beef cattle. But to South Dakotans of the era, that made him a stock grower and astute businessman more than a cowboy. While he possessed skills for riding in rodeos and, in fact, for organizing full public rodeos, that was more play than true cowboying. No, what made Berry a cowboy by South Dakota standards was the fact that he had worked cattle on the open range before it was broken up by barbed wire. At age twenty-three, South Dakotans knew, Berry rode in the great 1902 roundup, forever securing a historical status hard to top in the state.

He didn't live deep enough in the twentieth century to see the term *cowboy* devolve into something ugly in the thinking of some Americans—implying a mentality that initiated roughshod action without analysis, as in "cowboy diplomacy." During Berry's time in politics, humorist Will Rogers's genuine western background and sly, free-spirited observations epitomized a cowboy to millions of Americans. People who met Berry regularly said that he reminded them of Rogers, and in fact, the two became friends. But at the same time, Hollywood was reshaping the cowboy image into what South Dakotans considered sentimental mush. Eventually, offensive movie melodramas suggested that cowboys were mostly synonymous with gunslingers and avowed enemies of American Indians, an image Berry would have considered especially insulting.

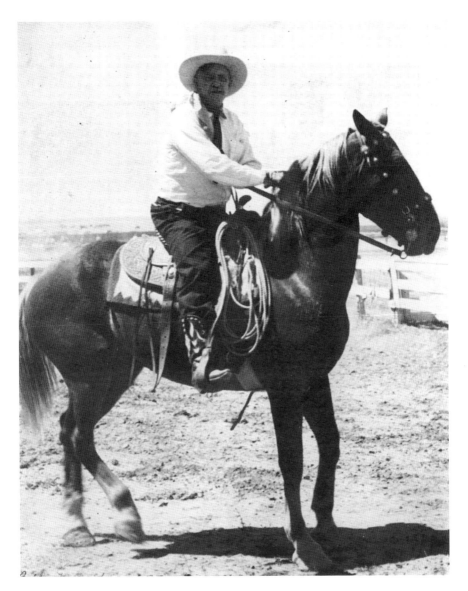

Tom Berry on horseback, as many South Dakotans first encountered him. *Berry family.*

Double X livestock. *Berry family.*

South Dakota constituents who never met Berry one on one knew his quips, often reflecting cowboy-country perspectives. For example, he possessed a westerner's distrust of people who didn't work hard, who didn't "earn their keep." When someone asked Berry how many state employees worked at the capitol, he replied, "About half of them."[3] Lots of people would remember seeing Governor Berry on horseback, opening a rodeo or as part of a parade through town. A few held memories of the governor fast asleep in their home, snoring on the floor. In farm and ranch country, it was customary for early rising farmers and their hired hands to come to the house after hours of morning labor, eat a noon meal and then drop into a chair or onto the porch floor for a short nap. If Berry was invited for a noon meal while touring rural country, he joined the ritual.[4]

Tom Berry was born on April 23, 1879, in Holt County in Nebraska's north-central section. The fifth of James and Cynthia Berry's ten children, he grew

up on a series of Nebraska farms as his parents moved frequently in search of better land. As an adult, Berry didn't recall childhood games or play. He worked on the farms as soon as he could contribute to the family's livelihood. Young Tom developed a confidence that told him he could grow any crop and handle any form of livestock.[5]

The time of Berry's birth coincided with the start of a great migration into western Nebraska and western Dakota Territory from the south. Texas cattle companies moved herds north in search of grasses that were both nutritious and free. The open range was federal land, running unbroken from Texas to Canada if company bosses knew the right routes. This vast expanse was the only way Texas cattle operations could expand after that state's ranges were overgrazed by the late 1870s. Not only did the federal government offer free grazing, but it also purchased much of the beef produced to meet treaty obligations for feeding people on American Indian reservations. Meanwhile, railroads were eager to extend lines into the upper Great Plains and ship beef to markets across the continent.

The Texas migration not only built a foundation for what would become Berry's ranching career, but it also shaped Nebraska and the future state of South Dakota in a way good government leaders had to understand. Another Dakota cowboy who would turn politician, Theodore Roosevelt, grasped why fully, writing that eastern Nebraska, and Dakota Territory east of the Missouri River, were midwestern, like Iowa and Minnesota. But farther west, residents were economically and culturally aligned with Texas because of the cattle industry. Usually American settlement advanced from east to west, Roosevelt observed, but in Great Plains cattle country, it had "gone northerly rather than westerly."[6] It could be said that when South Dakota achieved statehood in 1889, its eastern farmers and western cattlemen understood one another no better than they did Maine lobstermen. Yet, as citizens of a state that would never top 1 million in population, there were times when they had to come together or risk being lost in the shuffle of national affairs. Effective political leaders would be the best bet for achieving that fusion. The two regions of South Dakota would forever be called "East River" and "West River."

There's no evidence that young Tom Berry gave any thought to the state in its embryonic form immediately north of Nebraska, or to Great Plains politics. It's certain, though, that he knew of cowboys, laboring just a few days by horseback from where he grew up. These very first American cowboys were boys indeed. Those age thirteen, fourteen or fifteen were considered just right for riding away from home for months, trailing cattle for hundreds

of miles, sleeping maybe three hours a night and braving rattlesnakes, lightning strikes, flooded river crossings and dozens of other hazards.

What of the other nineteenth-century American frontier, the one of desperados and quick justice that dime novelists (and later Hollywood) seized on? Did Tom Berry experience any of that as a boy? Apparently at least once. No one was more despised in those parts than cattle rustlers and horse thieves. One horse thief, Kid Wade, notorious across a wide area, was captured on or near James and Cynthia Berry's land. A court quickly convened, and the thief was sentenced to death by hanging. James Berry offered a secure room in the family home as a holding cell until justice could be served. To the end of his days, Tom recalled peeping through a keyhole and catching a glimpse of a genuine frontier villain.[7]

The year Tom turned seven, the upper Great Plains endured a winter that put many cattle operations out of business, including Teddy Roosevelt's up in Dakota Territory. Low annual precipitation west of the Missouri River lured cattlemen to bank on "open winters," meaning shallow snow cover with grass protruding. As Tom would come to understand, those conditions translated to good winter nutrition for cows. They grazed on living grasses, and as they ate, they inhaled moisture rather than dust. But the winter of 1886–87 hit early, with lots of snow and bitterly cold temperatures. Grasses were buried deep as blizzard after blizzard pounded the plains. Most cattle perished, and their bones littered the prairies for years. Some future historians would write that the disastrous season spelled the end of the open range and big cattle outfits. But as Berry could attest, it didn't. A dozen years later, he would draw paychecks from big cattle companies as a cowboy and ride the open ranges of South Dakota. He would always understand the lessons of 1886–87 that kept the beef industry viable. First, cattlemen couldn't overgraze because underfed cows were in grave danger when hard weather gripped the plains. Second, it was vitally important for the industry to breed livestock best suited to weather extremes (he would eventually earn a reputation for crossing Herefords and brahmas).[8]

The year Tom was ten, the big block of country north of Nebraska achieved statehood. It can be argued that no state in history got off to a more painful start. Missteps of the late 1880s would haunt South Dakota political leaders for generations. When Theodore Roosevelt described the differences between eastern and western Dakota, he neglected to mention the middle. That's where the worst pain was felt, on American Indian reservations.

Just before the state was admitted to the Union, the federal government broke up the big Great Sioux Reservation, establishing five much smaller

ones west of the Missouri. The breakup signaled to railroads that they could now build lines across western South Dakota, but trains didn't show up for years. Immediately, though, the Lakota people saw their economic conditions worsen and sensed that they were penned in as never before. In December 1890, Big Foot's people were moving cross country, far from their reservation, when they were intercepted by U.S. cavalrymen at Wounded Knee Creek. As soldiers checked for weapons, a shot rang out. In an instant, a volley of gunfire filled the winter air, including the roar of Hotchkiss guns—an early version of the machine gun. The first reports said that 142 Lakota people died, including 58 women and children. There's no doubt more died later. Some tribal elders claimed that Lakota fatalities approached 300. Cavalry fatalities were 31.[9]

Many factors combined to bring about the Wounded Knee tragedy. One was sadly political. South Dakota's new U.S. senator, Richard Pettigrew, appointed James Forsythe as Indian agent at Pine Ridge, mostly as a political favor. Forsythe had virtually no background that qualified him for the job and could do nothing to intercede as the cavalry met Big Foot's band.

While still a teenager, in the late 1890s, Berry rode north into South Dakota and picked up cowboy work. In 1901, at age twenty-two, he went to work on brother-in-law George Lamoureaux's ranch near the present-day town of Winner.[10] It was an open range outfit and paid cowboys twenty-five dollars a month. Berry's work ethic attracted the foreman's attention, and he was among just a few hands kept on through winter, delivering hay to cattle by wagon—four to six wagonloads a day. But a cowboy's main work happened in spring and again in fall, during roundups. Then Berry and his fellow hands were in the saddle sixteen to eighteen hours a day, riding in search of cattle belonging to several area livestock companies. The cattle were pushed to central locations and sorted by ownership, indicated by brands burned into hide. All cattle were gathered in the spring during a "calf roundup," so named because that's when newborns were counted and branded. Every livestock outfit had a "rep" present to make a count. In the fall was the "beef roundup," when four-year-olds ready for slaughter were sorted out from the herd and moved cross country to points of sale. Depending on the number of cattle to be rounded up, spring or fall, the work could last from just a few days to a couple weeks, and crews could range from a half dozen to several dozens.

Roundups were where cowboys best learned the nature and temperament of cattle. Some gathered up easily, while others, in this world without fences, eluded pursuers by dropping into steep gullies or hiding in vegetation along creeks. Sometimes a cowboy rode a couple miles or more to intercept a single cow.

South Dakota cowboys would later scoff at the notion of Hollywood cowboys riding tall in the saddle. Lincoln A. Lang, an Irish-born cow hand who arrived in Dakota before statehood, recalled that "almost invariably you found us slumped down in the saddle, riding loosely, merging ourselves with our mounts, so to speak, as far as we might, there being no other way in which we could average 17 hours per day in the saddle and get away with it."[11]

Crews moved across the wide plains, working different locations from day to day. But every day started the same way and at the same time: 3:00 am. "Come and get it or I'll throw it out!" was most any cook's standard call to breakfast on the range, not spoken entirely in jest. Everyone, including the foreman, was expected to conform to the cook's schedule. There could be no greater sin than letting your horse kick up dust near the chuck wagon as food preparation progressed. The chuck wagon was also where cowboys stowed blankets, along with a very few personal items if space permitted. A water barrel was strapped to the wagon's side. The noon meal might consist only of a long drink of that water and chokecherries or wild plums found on the prairie, but supper would be substantial, with beans, potatoes, coffee and maybe beef. If beef was on the menu, the men slaughtered a yearling late in the afternoon.

A working South Dakota cowboy, in addition to learning about cattle, came to know the state's rugged landscapes and volatile weather. Ike Blassingame, Berry's contemporary who also came to South Dakota for cowboy work and never left, described the state's western half as the natural domain of "wolves, coyotes, wildcats, beaver, and rattlesnakes— wild and somewhat desolate, but country a cowboy loves."[12] Those who saw nothing to love (and there certainly were some) knew there were easier paychecks to earn elsewhere and typically were gone after a season. Both lovers and detractors of the region would forever tell weather stories, describing lightning, tornadoes and hot winds that pushed wildfires— all of which could kill cowboys and livestock alike. Blizzards could kill, too, of course, but some cowboys considered prolonged drought the very worst weather hazard. Cattle would wear down in the heat, risk of grass fire increased and sometimes the livestock would sink into deep mud

where water usually flowed. When that happened, the animals usually died agonizing, drawn-out deaths.

Berry's fellow cowhands in South Dakota were more diverse than most people today guess. Southern cowboys with Texas or Oklahoma roots were well represented, as were a surprising number of men from the British Isles—the source of so much capital that launched the America beef industry. Often outnumbering both southern and British cowboys on roundups were Lakota men. It's impossible, in fact, to imagine the cowboy culture as it took form in South Dakota without a strong American Indian presence, especially local Lakota men. Lakota bred and trained horses ranked among the very best a cowboy could ride.

Men who succeeded on the range, whatever their backgrounds, conformed to a culture that valued straight talk above all else. Exaggerating about skills, covering up mistakes, rationalizing instead of facing the facts or outright lying could lead to disaster—could kill a man. Later in life, Berry had no use for liars and considered being called one the gravest of insults.

Something Berry took away from his cowboying years was a big voice, the kind that carried across great distances and over pounding hooves and bawling cattle. Later in life, in any situation, Berry could command instant attention with a shout, a piercing whistle or a cowboy "whoop!"

Just as Berry made South Dakota home, the state dealt with a couple hard, snowy winters. They didn't rival the winter of 1886–87 but did put open range cattle on the move in search of grass. Livestock migrated south toward the South Dakota–Nebraska line and found areas of open grass on the Pine Ridge and Rosebud Reservations (especially the Rosebud). Some observers suspected the cattle didn't locate the grass on their own but were driven that way by cattle companies. Sixteen cattle companies were found to have animals on the reservations (brands proved it) but denied they played any role in putting them there. By 1902, tens of thousands of cattle were eating reservation grass, the federal Indian Service Agency was saying no one asked permission and the federal government was reminding cattle companies it could charge them $1.25 per animal if it decided to assert its authority.

That's exactly the action President Theodore Roosevelt decided to take if South Dakota cattlemen didn't move fast. Roosevelt knew exactly what it took to organize a roundup, and he told the sixteen companies they better stage a big one. If the cattle weren't moved, the fine would

be imposed and maybe the Rosebud would be fenced, with cattle left within lost forever. The president, in office just a few months at that point, signaled a theme that would be central to his administration: big business, the cattle industry included, would not flout federal regulations.

As for individual cowboys, Roosevelt knew what would be required of them. Roundups in general, he wrote, involved intense work, hardship and exposure and yet were pleasurable. Roosevelt added that roundups were health promoting and noted that of all types of physical labor the "pleasantest is to sit in the saddle."[13]

A total of 450 cowboys, Tom Berry among them as a rep, went to work in the late spring and early summer of 1902, seeking out more than fifty thousand head of cattle across thousands of square miles, from the Missouri River to the Pine Ridge Reservation's west end. Of the sixteen cattle companies, an outfit called the "73" owned the most animals—about thirty thousand. For that reason, "73" foreman Henry Hudson was selected the roundup's overall boss. His plan was to push livestock to a central point at the fork of the White and Little White Rivers.

Berry and the other cowboys owned their own string of horses but had to be proficient enough to ride specialty horses the companies provided in certain situations. Horses with great stamina could be put to work "rolling out the miles" as they swiftly covered South Dakota's vast distances. Others were strong swimmers, unafraid of water. "Cowy" horses possessed a sense for what cattle would likely do and could focus on a single cow and cut it out of a herd. All cowboys rode into situations in which they had to trust not only their mount but also its trainer.

For three months, the 450 cowboys chased cattle, ate dust on the trail and grub from chuck wagons, survived mishaps, watched the sky and movement of grass for changing weather and endured sweltering days and chilly nights. Above all, they got the big job done. Fast friendships took root, not unlike bonds soldiers form after going into combat together. The men would always be known as "the 1902 cowboys" in South Dakota history and lore. As for Berry, who would achieve tremendous success in business and politics, it seemed his status as a veteran of the 1902 adventure would always be the source of his deepest pride.

Berry worked at the Lamoreaux ranch another two and a half years after the great roundup, earning a reputation among fellow hands as a spendthrift. They noted he always stashed away a big portion of his paycheck. Berry's

goal was to accumulate $1,000 and set himself up on his own South Dakota ranch. He wouldn't be alone in the venture because he planned to marry a girl back in Nebraska: Lorena McClain, known to all as "Rena."

Born in Missouri, Rena moved with her family as a young child to Springview, Nebraska. She attended school in Springview and became a local teacher there upon completing her own studies. In March 1905, Tom and Rena were married at her parents' home. The couple's first home would be a cramped "wagon house," able to be transported from spot to spot by wagon and a horse team. Tom arranged to borrow it from the Lamoreaux ranch after acquiring 160 acres from a homesteader ready to give up on a place, twenty miles southeast from the ranch, near the fledgling town of Gregory.

In Rena, Tom had found a life partner who was soft-spoken, friendly and confident and competent in whatever task she put her mind to. Sharing her husband's farm background, she would prove unflappable whether handling farm/ranch chores or learning to steer a heavy wagon drawn by a four-horse team across the rutted prairie.

The couple traveled first to the Lamoreaux place, where it appears Rena waited as Tom and some pals moved the wagon house out to the new Berry property. When they returned, all of Tom and Rena's worldly goods were loaded onto the wagon. Tom hitched a team, comprising just-broken horses, to the wagon and began driving it to the spot where his bride would climb aboard. He seldom had trouble with horses but found he couldn't stop these. The wagon dashed by Rena, and Tom called out, "Wait there, I'll be around again!" He made a couple wide circles and wore the horses down a little, and if he didn't entirely stop the wagon, he at least got it moving slowly enough for Rena to hop aboard. They reached the little house at sunset.[14]

The Berrys planted corn that spring because they were required to plow land under Homestead Act regulations. There's no doubt, though, that they considered cattle ranching their future. Berry believed the grasses west of the Missouri River in South Dakota to be the best on the Great Plains. Even though he had his own place, he made extra income hiring out to help neighbors with small roundups, branding and threshing grain. On the Fourth of July that first year, Tom and Rena had a dollar with which to celebrate and decided to attend a dance at Gregory. They came home with five dollars because the dance's organizer feared that local toughs might enter the dance hall, hurl insults at men in front of their girlfriends and provoke fistfights (a common occurrence at early

South Dakota dances). The organizer, who knew Tom as a commanding presence and a thoroughly tough man, hired him to keep order. Berry stood only about five feet, eight inches but was impressively muscular. That night in Gregory, there was no trouble.

It soon became apparent that lots of extra work Tom could pick up would be on threshing crews, as the Gregory area was proving itself good farmland. That didn't bode well for cattle ranching, requiring big unplowed surroundings. Tom and Rena, although they built a more substantial home after several months in the wagon house, were ready to leave on a quest for better cow country. They moved onto the Rosebud Reservation for a while and then left the state for land near Nebraska's Sand Hills. Tom traveled to Wyoming and bought livestock, but the couple sensed they hadn't yet found the best grassland.

Meanwhile, homesteaders were flowing into Gregory County. The Chicago and Northwestern Railroad offered special fares for people hoping to relocate "out West." After riding the rails into Gregory aboard the line's trademark yellow cars, would-be homesteaders paid fifteen dollars to enter a land lottery. Winners were awarded land they had to improve to gain full title; often, spouses entered the lottery separately, hoping to arrange two adjacent homesteads. Future president Harry S Truman, in 1911, decided to try his luck in South Dakota. He rode in a crowded Chicago and Northwestern car to Gregory and never forgot the trip, which he considered a great adventure. He recalled fellow travelers hurling insults at one another, good-naturedly or not, including "go to hell," because they were competitors in this land grab. Truman spent a night in a Gregory hotel lobby and the next morning registered for the lottery in a community hall (maybe the same one where Tom kept order during that Fourth of July dance). Then Truman boarded another yellow coach and returned to his native Missouri. He later learned that his name wasn't drawn in the lottery.[15]

If it had been drawn, Truman could have lived in proximity to another Democrat who would develop political ambitions: Tom Berry. In 1912, Tom and Lorena learned that Mellette County, west from Gregory County and close to the Pine Ridge and Rosebud Reservations, would be organized. Tom knew the country well. It was rugged and, he believed, would always remain cattle land, watered by the strong White River and good creeks, encompassing the central spot where cattle were driven in the 1902 roundup. By then, Tom and Rena were parents of two sons and two daughters, all under age seven: Baxter, Nell, Faye and Paul.

Averaging fifteen miles per day for more than one hundred miles, the family moved to Mellette County, with Rena handling the wagon's reins. Baxter, age seven by the time the Berrys set out in April 1913, mounted a horse and helped his father drive about forty head of cattle. All the Berry children grew up fast and were given responsibilities vital to the family business.[16]

On April 28, with the grass greening nicely and meadowlarks in full voice, the family reached their new home. It was a patch of land around which Black Pipe Creek flowed. There were trees for a wood supply. A quick horseback ride brought the stark white alkali and dramatic spires of the Badlands into view. From a Lakota man Tom bought wagon loads of cedar logs, enough to build a thirty- by sixteen-foot home—practically a mansion in that part of the world. Initially, the Berrys built no fences and instead turned their cattle and horses onto the open range.

Gray wolves were a regular threat to livestock. Especially before dawn, Berry later remembered, the family would hear horses running and cattle bawling and knew a wolf pack had arrived. Wolves surrounded a targeted animal (they especially liked colts), latched on and pulled it down and then ripped flesh and ate. Wolves, Berry would tell rapt listeners after the predators were mostly gone, liked their meat fresh and warm. They left cold carcasses that coyotes ate from, and finally buzzards flew in to pick the bones clean. Of course, wolves could target children who

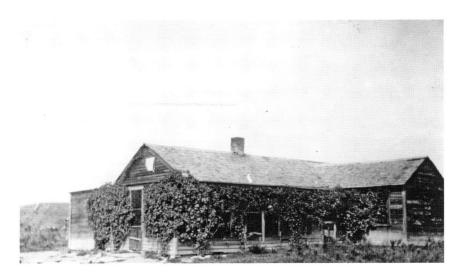

Original Berry home on the Double X ranch. *Berry family.*

wandered away, too. For a few years, children who grew up on West River ranches, as the Berry siblings did, heard about wolves in much different ways than city children, who considered them wily fairy tale characters. Mellette County ranchers shot wolves when they could and offered bounties for hunters who pursued them aggressively. By 1918, the county was considered wolf-free.[17] Coyotes would never be eradicated, but Berry reduced the population on his place with the aid of a dog breed he admired: the greyhound. These dogs easily outran coyotes and were ferocious fighters that could routinely tear their prey apart. Berry never lost interest in these canine allies and late in life found another purpose for keeping them.

The best allies Berry ever had were his brothers, Cleve and Claude. They moved into the area, Cleve in 1914 and Claude in 1916, and each set up his own ranch operation. Two of Tom's sisters, Elva and Chloe, arrived as well but did not stay long. The three brothers helped one another when one of them scheduled a branding or had cattle to move, and they enjoyed joining forces for a hunt (especially coyote hunting). Their families and others nearby socialized together, with Tom and Rena's house often the setting for dances. There never seemed to be a shortage of ranch country musicians who owned guitars, mouth harps, banjos and fiddles. Rena had hauled a piano by wagon to the ranch, and it became part of impromptu dance bands. Sometimes,

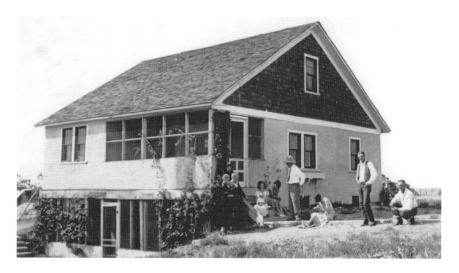

Years later, the family built a more modern home on the ranch. *Berry family.*

when the night was pitch black on the range and dangerous animals still prowled, dancers and musicians waited for dawn to return home.[18]

Good horses were vital to all of Berry's ranch operations, and nothing frustrated him more than losing one to a band of wild horses that ran through the Badlands. When that happened Tom, Baxter and Paul mounted up and rode in pursuit at breakneck speed, across rugged country, ropes ready to lasso the runaway. Sometimes the Berrys succeeded but found the animal's character altered by following wild horses, even briefly. The Berrys once rescued a neighbor's horse, but the man could never ride it again. On the other hand, Paul once came upon a wild colt that was separated from the herd during a chase, brought it home, fed it cow's milk and broke it for his own.[19]

There was obviously plenty for the children to learn on the range, but that didn't mean Tom and Rena neglected formal education. The family built a little schoolhouse in their yard, and the county supplied a teacher. Originally, the Berrys were the only students. Teachers were boarded in the family home, a hospitable setting, yet the overall isolation unnerved most teachers (usually very young women). A hard winter could delay mail for weeks. Some years, teachers came and left at a rate of three per term. At times, Rena became the teacher, drawing on her experience at Springview. "And it was funny," she recalled. "When I got in the school room with them, they seemed like the pupils I used to have instead of my own children."[20]

Meanwhile, Tom left the house early every morning, working to build up the ranch by fencing off acres with barbed wire, developing good hay fields, cutting hay in season and, of course, tending to livestock every season. One of the most rigorous daily chores was chopping ice all winter to keep water sources open for cattle and horses. In his work, Tom was assisted by a few hired hands. He was a rancher always willing to hire a Lakota hand. He told acquaintances that the Lakota people knew Mellette County land and weather patterns best, and he sometimes referred to himself as an Indian—as in "we Indians"—if he thought his Lakota neighbors were being neglected or mistreated by government.

He sometimes bought out a failing homestead and then offered the seller a job. The Berrys also leased grazing land on the Pine Ridge Reservation, negotiating in those years with Lakota individuals rather than the tribe. Between buyouts and leases, the Berry ranch came to encompass thirty thousand acres, eventually extending into present-day Jackson County, with two thousand head of cattle at peak season.

Additionally, the family earned a reputation for selling excellent saddle horses.

As a highly successful cattleman, Tom became a respected voice within the industry—a voice that articulated sound thinking usually laced with humor. He fully understood that ranchers had to advance good business practices and gain a voice at all governmental levels. Tom became active in the Western South Dakota Stock Growers Association (later called the South Dakota Stock Growers Association). In the early twentieth century, the association grew as a political force, and alignment with it could certainly help an individual's political aspirations. Berry had such aspirations that apparently grew from a commitment he demonstrated immediately upon relocating to Mellette County, where leaders had to step up and create everything. His daughter Nell recalled growing up with a father who was "active in community affairs and helped promote roads and schools."[21]

He also promoted White River Frontier Days, one of the Great Plains' major annual rodeos, held several miles east of the Berry Ranch in the community of White River. Cowboys first gathered there for an informal bucking bronc competition in 1912, a year after White River's founding. A bigger competition played out the next year, with both participants and spectators spending liberally, prompting White River merchants to put up rodeo prize money. The event grew and became more elaborate so that by 1919 there were, in addition to bucking livestock, Lakota dance exhibitions, boxing, airplane rides for $25 and a parachute jumper who cost the community $400.

But nothing topped rodeo competition, especially saddle bronc riding in the days when cowboys rode until bucked off or the bronc gave up. Three-time world champion saddle bronc rider Earl Thode made rides in White River, as did other rodeo personalities from across the West. Those included woman saddle bronc rider Mildred Douglas and some of the pioneers of a brand-new rodeo feature: steer bull-dogging. Tom could be counted on to judge, and from 1923 to 1928, he served as arena director. For several years, brothers Cleve and Claude and their families joined Tom's family in running the show and providing livestock. Frontier Days meant exhilarating fun and enjoyable promotional trips by car caravan to cities as distant as Omaha. Usually Lakota dancers made those trips, donned traditional garb and fascinated the city dwellers.[22]

In the 1920s, tourism was still seen as the domain of railroads. White River had no rail service, but out-of-state vacationers made the trip anyway

by automobile via long miles of unpaved roadway. That said something about the potential that tourism held for South Dakota. Berry had lived a life so deeply immersed in authentic western life that he perhaps did not fully understand the American public's fascination with cowboys, bucking broncs and powwows until White River Frontier Days.

Chapter 2

POLITICS

The lore of the 1902 cowboys wasn't Theodore Roosevelt's only South Dakota legacy. He also inspired the political career of Peter Norbeck, governor from 1917 until 1921. More than anyone else, Norbeck would represent the standard by which all of the state's twentieth-century governors would be measured. But to Tom Berry's thinking, Norbeck also left behind some problems.

Born nine years before Berry in Dakota Territory to Norwegian immigrants, Norbeck made his living as a well driller. When he entered politics, he considered Roosevelt his "idol and ideal," a Progressive Republican like himself. That meant putting government to work to protect the interests of individuals (especially farmers) against those of big moneyed corporations. As governor, he established a state hail insurance program for farmers and put South Dakota government into the businesses of coal production, manufacturing cement and stockyard operations. Like Roosevelt, Norbeck believed deeply in conservation and was the force behind creation of a state park in the Black Hills that rivaled most national parks. His lieutenant governor, William McMaster, was elected to succeed him as governor the same day Norbeck won election to the United States Senate, in 1920, and McMaster followed the example of active state government.[23]

Berry believed Norbeck and McMaster went too far, and he noted that taxes farmers and ranchers paid were a main source for their program funding. Berry was a Democrat, in part because that's what his parents considered themselves in Nebraska but also because he saw Democrats

as the most consistent friends of those in agriculture. Daughter Faye recalled that Berry was always interested in government and that he often discussed political issues over the family dinner table. "Now, I think maybe he thought that was a good time to bring home a few lessons for us kids," Faye said. What's more, she added, her father was a natural for addressing those issues himself as a politician. "Everywhere he went he met people, because he'd always go up and start talking to anybody," she remembered. "And he always listened to them. He always wanted to hear their side of how things were—what was going on."[24]

In 1924, Berry ran for the South Dakota legislature (House of Representatives) as a Democrat. He won. In those years, the legislature met for sixty days every other winter (1925, 1927 and 1929 during Berry's tenure).[25] Leaving home for a while was nothing new for Tom and Rena's family. A few years earlier, Rena and the children began spending the school year in Rapid City so that the four young Berrys could enroll at Rapid City High School. Tom's service in the legislature took him nearly one hundred miles northeast from the ranch to the capital city, Pierre, in the state's middle, far from population centers. For legislators like Berry, who drove in by car, time spent navigating rutted dirt roads was a reminder of how rural South Dakota was and why plans for improving roads were constantly discussed and debated in Pierre. Berry had purchased a big Buick in 1918, with jump seats for the children. After taking possession of the car, he had to find someone to teach him how to drive it.[26]

Berry found himself both amused and a bit annoyed by the showmanship he saw in the legislature, and he dubbed sessions "The Follies." But he thoroughly enjoyed the camaraderie with fellow Democrats he met. In capitol building back rooms and over dinner and late-night drinks downtown on cold winter nights, Berry and his colleagues discussed building Democratic majorities in both legislative houses. They also talked about what it would take to elect a Democrat as governor. That hadn't happened in South Dakota history, although some journalists of the time noted that Louis Church, a territorial governor in the 1880s, was a Democrat. Now, four decades later, Berry and friends sensed growing dissatisfaction for Republican policies within the agricultural sector. Farmers and ranchers of the 1920s faced depressed prices for their products, and many felt that taxes against their properties were footing the bills for government services South Dakota could no longer afford. In general, Republicans were seen as fiscally liberal compared to more conservative Democrats, although matters were complicated by a

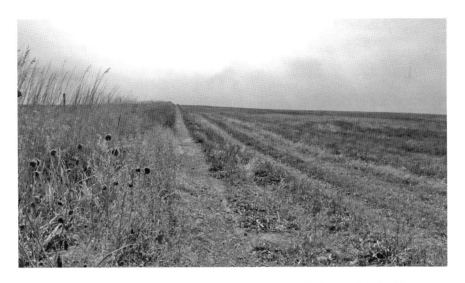

Road improvements across the wide, rural state were constantly discussed during Tom Berry's tenure in Pierre. *Author's photo.*

gradually developing Progressive wing of the Democratic Party (a wing that would often clash with Berry in coming years).

For a while, the popularity of some of Governor McMaster's progressive (actually socialistic) initiatives slowed inroads by Democrats. For example, in 1923, McMaster went head to head with Standard Oil by putting the state into the retail gasoline business. That August in Washington, D.C., as McMaster mourned President Warren Harding at a state funeral, he was well aware of a developing crisis back home. Just as farmers were preparing to haul their harvests to market, gasoline prices hit twenty-six cents per gallon—about a dime per gallon more than McMaster felt was right. Returning to South Dakota by train, the governor stopped in Chicago and told Standard Oil that the state would sell gas to the public for sixteen cents per gallon until the company played fairly (he had done his homework and believed Standard Oil could still profit nicely at sixteen cents). The action spurred a gas pricing war involving other producers across the Midwest and Great Plains, succeeded in reducing prices and was obviously well liked by South Dakotans. The United States Supreme Court later ruled that this type of government interference with free-enterprise pricing was illegal.[27]

In the legislature, members elected or reelected along with Berry in 1924 initially had reason to believe that they would address enhancing the state's physical infrastructure. The 1920s were to be the period when South Dakota state government developed Missouri River hydroelectric plants for public

power. But the public signaled, through ballot referendums, that it wanted physical infrastructure projects scrapped.[28] Instead, legislators were told, it wanted to see South Dakota's fiscal infrastructure fixed, both in the private and public sector. Highly alarming was a rash of bank failures.[29] Equally alarming in Berry's thinking was the situation with the state's Rural Credit program. Governor Norbeck had established it to loan money to farmers, to protect them from banks that might manipulate interest rates and be unabashed about foreclosing. The program took root in 1917 when the farm economy was strong, but by 1924, one-third of farmers who took loans couldn't make payments. The Rural Credit office was $45 million in debt, and more than $27 million was due in interest.[30] For Berry, always leery of debt in his personal and professional life, the Rural Credit spectacle was horrifying. South Dakota, he believed, had to at least keep up with interest payments to bond holders so they wouldn't accrue and overwhelm the entire state budget.

By advocating fiscal responsibility, Democrats had believed they had a chance to win the governorship in 1924 with highly regarded legislator Andrew Anderson as their candidate. Anderson farmed at Beresford, close to the Iowa border in South Dakota's southeast corner. Six weeks before the election, a bull charged Anderson and killed him. The party replaced him on the ballot with another Beresford man, attorney William Bulow. He had served ably in the state legislature, as Beresford mayor and as that community's longtime city attorney.[31] But he lost the governorship to Republican Carl Gunderson by a two-to-one margin. South Dakotans simply didn't know Bulow, but Berry came to know him as well as he knew anyone in politics. In fact, observers said, the two Democrats resembled each other in manner—both were business-savvy, wry, unafraid of conflict and fond of tobacco and wisecracks.

Bulow ran again for governor in 1926. By then, thanks to investigative work by the 1925 legislature, South Dakotans better understood the Rural Credit dilemma, and things weren't looking good on other economic fronts, either. To Berry's delight, Bulow became the state's first Democratic governor, defeating Gunderson by thirteen thousand votes. Republicans retained control of the legislature, keeping Berry in a role to which he was by now accustomed: a vocal part of a minority.

Governor Bulow firmly believed that South Dakota had to balance its state budget. In 1927, he vetoed a general appropriations bill passed by the legislature because, by his calculations, expenditures would greatly exceed income. The veto offended Republican legislators, and they refused to pass

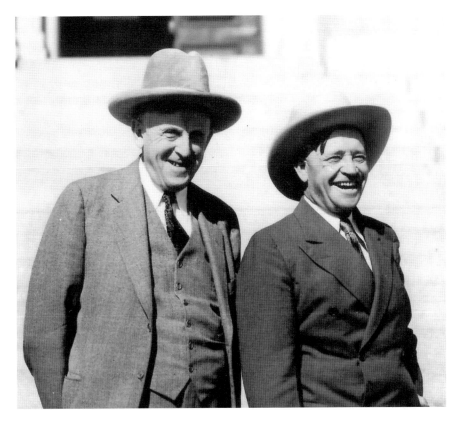

William Bulow and Tom Berry were two of a kind, tough and wisecracking. *Berry family.*

any more bills. Bulow wouldn't back down. His opponents couldn't muster votes to override the veto, and when the session ended, legislators went home with plenty of unfinished business. It took a special session of the legislature, called by Bulow, to bring about a budget for the next two fiscal years. The governor's stance played well with voters. Bulow would be reelected governor and then won a United States Senate seat.[32]

With key victories in the Pierre capitol building and at ballot boxes statewide, Berry and fellow Democrats enjoyed clout unimaginable a decade earlier. Simultaneous with Berry's rise in state government was his leadership within the South Dakota Stock Growers Association. He was selected for the association's executive committee in 1922 and continued to serve in that role concurrently with his government service in Pierre.[33] He had paid his dues to the Rapid City–based association all his years as a rancher, attended

its conventions and supported its missions—publishing brand books vital in confirming animal ownership and lobbying for legislation helpful to the beef industry. As the agricultural crisis of the 1920s grew, West River cattlemen (as well as wool producers) were certain that South Dakota state government routinely put the interests of East River farmers ahead of theirs. It was the main East River–West River split of the time. In short order, both farmers and ranchers would air their opinions with the president of the United States, Calvin Coolidge, during a summer-long visit to South Dakota.

That opportunity came about because of Peter Norbeck, primary creator of a Black Hills haven fit for a president: Custer State Park. Much of the land was pine forest, and there were steep mountains capped with spectacular granite outcrops, including sharp spires called the Needles. There were also vast meadows that had led Norbeck, in 1911, to decide that the location was ideal for a game preserve. Norbeck was a state legislator then, and in that position and as governor and U.S. senator, he never ceased laboring (sometimes physically) to advance his park project. As for game in the preserve, bison were most notable, descendants of animals rescued by a Lakota-French family, the Duprees, and a Scottish immigrant to South Dakota, Scotty Philip. As governor, Norbeck knew that visitors from across

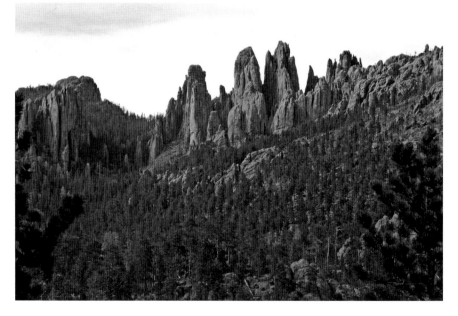

The Needles are spectacular granite formations high in the Black Hills. *Ryan Phillips.*

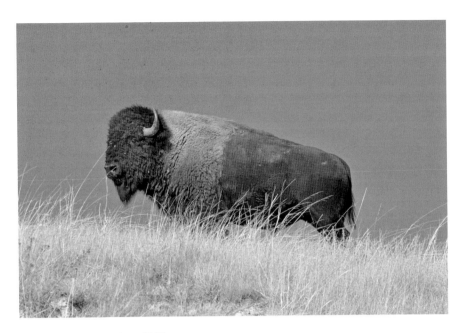

South Dakota bison. *Ryan Phillips.*

the nation were traveling to South Dakota to view the bison and other Custer State Park natural wonders. With engineer Scovel Johnson, he walked a rugged route to lay out one of the world's truly stunning automobile roads, the Needles Highway, blasted through granite.[34]

Berry knew that history, as well as about the remarkable C.C. Gideon's Custer State Park construction projects of the 1920s, topped by his State Game Lodge. The lodge stood as a residence Norbeck decided could serve as a Summer White House. President Coolidge wanted to escape Washington, D.C.'s summer heat and humidity in 1927, and Norbeck assured him he'd find no better destination than the Black Hills.

Coolidge; his wife, Grace; their dogs; the White House staff; and a small army of newspaper and magazine reporters arrived by train in June. For the rest of the summer, the president would be chauffeured thirty-five miles most days from the State Game Lodge to Rapid City High School, where offices were set up for him and his staff. He made time in the park for trout fishing, watching bison and other wildlife and entertaining guests in this unique presidential setting. Most famously while in the Black Hills, he decided he wouldn't seek reelection the next year and issued his terse, "I do not choose to run for President in 1928" statement at the high school.[35]

The State Game Lodge served as President Calvin Coolidge's "Summer White House" in 1927. *Ryan Phillips.*

President Coolidge learned that the Black Hills were a good location for meeting with constituent groups, not only from the Midwest and Great Plains but also from points farther west, too. He greeted American Indian delegations, farmers and ranchers, schoolteachers and Wyoming leaders, plus groups from western Canada. He spoke to members of the South Dakota legislature and welcomed future president Herbert Hoover to South Dakota. Cattle producers from across the West, part of a beef marketing coalition, met with the president to say they didn't need much from the federal government—certainly not price controls—but support for co-operative marketing efforts would be appreciated.

A meeting of farmers at Ardmore, a tiny town south of the Black Hills, turned contentious thanks to Governor Bulow. The president, both South Dakota senators and the governor attended. Bulow didn't like the idea of government price supports for farm products but said the nation was at risk of moving that way because a discriminatory "Republican tariff" was damaging the agricultural economy. Coolidge sat stoically as the governor scolded Republicans but made no reply (he had said in advance he would attend but not speak). But Senator Norbeck stood and replied to Bulow, saying that one thing worse than a Republican tariff was a Democratic tariff.[36]

The national press corps was always interested in comments South Dakota's governor might offer, and Bulow complied but didn't always enjoy the exchanges. He complained that a *New York Herald-Tribune* journalist not only misquoted him but also misidentified his choice of chewing tobacco.[37] Word spread quickly among writers that the legislator from Mellette County was another good source. As a state official with special interest in the state park (he sometimes donated hay for its wildlife), Tom Berry was around a lot, with an outgoing manner, an endless supply of quips and a deep insight into the Black Hills, surrounding plains, cattle, bison, local characters living and dead and much more. Berry later recalled the summer of 1927 as the time he first realized he possessed a knack for speaking to the press—and that he enjoyed it.

Bulow was reelected governor in 1928, and he appointed Berry to the Custer State Park Board of Directors.[38] Herbert Hoover was elected president. Berry would come to despise Hoover, often citing the president's inability to rescue millions of Americans from hunger in the early 1930s.

The stock market collapsed in October 1929, and national economic trauma followed. Nationally, Senator Norbeck won the respect of Republicans and Democrats alike when, as chairman of the Senate Banking and Currency Committee, he directed an aggressive investigation into New York Stock Exchange practices.[39] By the time of the investigation in 1931 and 1932, however, most of Norbeck's fellow South Dakotans were focused more on a new calamity. Severe drought was sucking the life from the entire Great Plains. It was the beginning of the Dust Bowl, which, combined with the economic depression, delivered unprecedented misery to the plains.

Bulow finished his second term as governor and joined Norbeck in the U.S. Senate in 1931. Republican Warren Green was elected governor. Berry considered Green's leadership at a time of widespread despair no better than President Hoover's. And there was something else about Green that angered Berry. The new governor took away Berry's membership on the Custer State Park Board. Although there were bigger issues in play, Berry family members believed that action by Green was a factor in Berry deciding to seek the governorship himself.

While in the legislature, Berry had caught the attention of Will Chamberlain, a *Pierre Capital Journal* newspaperman who liked his friendly nature, honesty, West River toughness and ready wit. There was a window in the capitol building that looked west across the town and river to the treeless, rolling prairie that was so different from East River's tilled fields. One winter afternoon, Chamberlain found Berry gazing out that window as the setting

sun colored the prairie rosy. "What's on your mind?" Chamberlain asked. Berry surprised Chamberlain by reciting verse:

Out where the handclasp's a little stronger,
Out where the smile dwells a little longer,
That's where the West begins...

He was reciting song lyrics that had become popular a decade before, from "Out Where the West Begins" by Arthur Chapman. Berry knew it well. Across the river, he told his journalist friend, was home. "I'm a real Westerner," he added, "but near enough to the East to be neighborly."

Now in early 1932, Chamberlain decided that Berry was a man who, as governor, could bring East River and West River together to fight through the 1930s. "Not only the state and nation, but the world as well are in the whirlpool of unprecedented depression," Chamberlain editorialized. "At such a time, we must look to our strongest sons and daughters—those who are willing to toe the line unflinchingly, who are willing and ready, like the understanding and courageous surgeon, to go deep if necessary. In Tom Berry, South Dakota has such a man of the hour—a modest, tolerant, forceful man who will face the music whether it be a melody or a lament."[40]

Chamberlain wasn't the only South Dakotan thinking along those lines. In early 1932, Berry drove to Huron for a Jackson Day dinner, where Democrats would start thinking about the May primary and November general elections. Berry attended, he insisted, just to "knock around" with friends he'd served with in the legislature. Some of those friends thought Berry should run for governor. His initial thinking was that he couldn't because of his concern for his cattle in Mellette County, trying to survive drought conditions. His livestock, Berry said, were eating cafeteria style, "helping themselves to a little food here and a little food there."[41] Within days, though, it seemed he grew enthused about the prospect of serving as South Dakota's chief executive. After all, his grown children could capably run the ranch.

Berry definitely had ideas for South Dakota. He didn't like the fact that livestock, East River and West River, were stressed, and Green seemed unable to drum up relief dollars for feed. Likewise, Berry believed that President Hoover was showing no imagination in helping farmers nationally. Sometimes in 1932 it would feel as if Berry were running against Herbert Hoover as much as against primary opponents and Warren Green. For example, "The Republicans are telling you not to change horses in the

middle of the stream," he said. "Now let's think about that a minute. Let's say I'm riding a cow pony and I come to a flooded creek. I jump him in and he goes to the bottom like he was a rock. Then he comes up floundering and down he goes again. Now do you mean to tell me that if a good strong-swimming horse happened to come along, I wouldn't quit the pony I was on and change right there in the middle of the stream?"[42]

There's a clue in that statement about why Democratic leaders were eager to see Berry win the nomination. The previous Democratic governor and current U.S. senator, Bulow, used homespun imagery along those lines, and it played well with voters and took him far. Much was said about Berry potentially becoming the state's first West River governor. But in fact, seeming to be a West River version of a popular East River Democrat was also a boost.

Berry committed to running. In the spring primary, his Democratic competitor was Wagner newspaper editor L.E. Corey. Another newspaper observed that "Corey is a scrapping editor and Berry a picturesque rancher."[43] From the start, Berry's statewide image was that of a cowboy, but he soon unveiled a campaign symbol that wasn't necessarily cowboy-like. His logo, instead of being a ten-gallon hat, lasso or branding iron, was an axe. He promised to wield it aggressively to prune waste from the state budget. "A state," he wrote, "like an individual, must spend less than its income if it's to keep its finances on a sound basis."

That, friends told him, was a message that could carry him to the governor's office. They also advised him to tone down the humor. He told the *Aberdeen American News* that he knew serving as governor was serious business but that his well-intentioned friends "can't change a fellow all at once…if that job stops a fellow from enjoying a joke it's pretty bad."[44]

He initially claimed to be no public speaker, yet no one was better at spinning a yarn and punctuating with a final punch line. South Dakotans quickly came to know that when Tom Berry came to town, whether or not they agreed with him, he was entertaining. Newspapers sometimes referred to him as "jovial Tom Berry."

But after the jokes, he came back to the axe. He said he knew homeowners and business owners alike feared losing everything due to the devastated economy and state government's apparent commitment to carrying on as usual. South Dakota, he said, needed a "governor who is determined to use the broadaxe and lop off the thousand and one useless branches of state government. I am willing to make the effort in hope that when your children and mine take our places that we can turn over to them a state that will be as

Berry ran well across most of the state in 1932 but didn't win Sioux Falls, South Dakota's biggest city. *Siouxland Heritage Museums.*

sanely and economically governed as South Dakota was when it was turned over to us."[45]

Democrats liked what he preached and in May gave Berry the primary win with 23,689 votes to Corey's 18,591. Because Berry won more than 35 percent of the votes, his nomination at the state Democratic convention in Pierre the same month was automatic. The convention did assign him a running mate for lieutenant governor, Hans Ustrud, more liberal and less enthused about using the axe than Berry. It would not be a happy association. The Democrats had their work cut out for them—Governor Green was re-nominated by the Republicans, winning 74,194 primary votes. Republicans' total primary votes cast for governor totaled 127,653, compared to a total of 42,280 cast for the Democrats. A big break for Berry came when former Republican governor Carl Gunderson, who had wanted his job back and ran against Green in the primary, threw his support to Tom Berry.

Before campaigning again, Berry said after the convention that he would work at his ranch all summer. It was the era when general election campaigns traditionally began on Labor Day.

Berry's plan of action that fall was to arrive in a big town, check into a hotel where he could meet with local Democratic leaders and hit the road the next morning for speeches in several smaller towns nearby before an evening talk in the big community. For example, on Wednesday, September 21, Berry left his

Mitchell hotel by car at 9:00 a.m. and encouraged supporters to join him in an auto caravan. He spoke at Loomis at 10:00 a.m., Mount Vernon at 12:30 p.m., Ethan at 4:00 p.m. and at Mitchell City Hall at 8:00 p.m.[46] Four or five speeches a day were typical. He began using the phrase "New Deal," following Democratic presidential candidate Franklin Roosevelt's lead. Often Senator Bulow, not up for reelection that year, shared the stage and urged voters to support Berry, Roosevelt and local Democrats.

Berry continued to pound Green for not doing enough for agricultural relief. Berry also mentioned his disgust about nepotism in Pierre. "If I'm elected, there will be only one Berry on the state payroll, and that will be Tom Berry," he promised.[47]

The state payroll became a favorite target, with Berry projecting that $700,000 could be saved in two years by reducing state employee salaries by 10 percent across the board. What's more, he thought, some jobs could be cut entirely without hurting services. And Tom Berry meant what he said, S.L. Martin of Belvidere wrote to newspaper editors. Martin knew the candidate personally and called him a "man's man, and self-made man, a he-man if you will have it so, a true product of that great West now so rapidly passing."[48]

In Arlington, Berry stopped by the office of *The Sun*, a stalwart Republican newspaper. As such, the editor wrote, the paper couldn't endorse Berry—but it sure would if only the candidate were Republican. The editor declared that "Mr. Berry is a congenial whole-hearted 'good fellow.'"[49]

Then, on October 28, with eleven days left in the campaign, it nearly ended in tragedy. Democratic state chairman Dave McCullough was driving Berry, former legislator Fred Eggers and Iowa newspaperman Joe Ryan to Sioux Falls for a rally. Near Colton, the McCullough car collided with another and rolled three times. Berry and everyone traveling with him were cut and bruised, and occupants in the other car were injured, too. But Berry insisted he would speak in Sioux Falls two hours later and did.[50] A doctor advised him to fully recover by resting several days, and Berry decided that meant two days. On October 31, bandaged as if made up for Halloween, the candidate began a campaign swing through the Black Hills and then crossed the plains north and east of the Hills, talking to anyone he could find in that sparsely populated area. He dropped south to the Pine Ridge Indian Reservation and then wrapped up the campaign November 7 with a cowboy parade through Rapid City's streets. The next day, voters went to the polls.

South Dakotans gave Tom Berry a major victory, 158,058 votes to 120,473. What's more, the state joined the nation in voting for Franklin

Roosevelt, handed the new governor a Democratic majority in the legislature and rejected every Republican selected by statewide voting—except for the highly regarded Senator Norbeck. An out-of-state newspaperman phoned, and Berry said, "All of the Republicans I have seen since election day have such long faces they could eat oats out of a churn."[51]

The governor-elect could be flippant with an outside writer, but he decided to follow the advice of those who urged him to dial back the humor as he thanked South Dakotans. He said that he felt a sense of gratitude "that is difficult to express. Realizing that I am but the servant of the people, I want to appeal for the support of all. With the cooperation of the Legislature, I am confident that it will be possible to give this great state an administration of economy without sacrificing efficiency."[52]

Berry would indeed use the axe. But in late 1932, it's unlikely he could have guessed how much his tenure as governor would be defined by another metaphorical rural tool: the lasso. He would aggressively rope federal dollars President Roosevelt designated for relief, jobs and land restoration.

Chapter 3

GOVERNOR

A ll South Dakota cowboys and ranchers knew Pierre not only as a seat of government but also as a center for the livestock industry. It sat on the east side of the Missouri River, directly across the water from smaller Fort Pierre. Not that Pierre was big. With a population of about four thousand in 1933, it was the second-smallest state capital city in the country, and it was possible to walk to most any in-town destination.

Pierre's Main Street retained a cow town feel (a pleasant quality to the thinking of many South Dakotans), and there was an impressive neighborhood of big, stately homes—some built by beef profits. The governor's residence wasn't of the caliber of those big homes. It was small enough to be called the "governor's cottage" by locals. On a ridge above the river and downtown stood the twenty-three-year-old capitol, a beautiful structure of sandstone, marble and granite capped with a 165-foot dome. In that era, it housed the offices of almost all elected state officials and Pierre-based state employees. The governor's suite of offices, in the west wing with windows looking south across town, sat one floor below the Senate and House of Representatives chambers and just down the hall from the Supreme Court.

As Warren Green left Pierre to resume life as a farmer in the northeastern part of the state, Tom Berry arrived from the southwest. Out of concern for the economic hardships South Dakotans lived with, the Berrys said that inauguration activities wouldn't require formal dress. Not surprisingly, observers counted more cowboy boots than they remembered seeing at any other inaugural. Berry took the oath of office the afternoon of January 5.

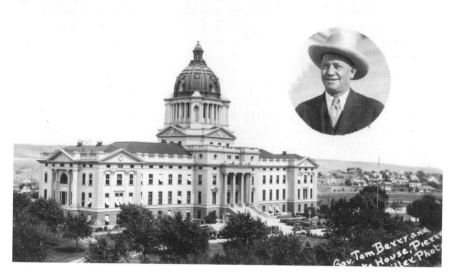

Pierre visitors could purchase picture postcards featuring the capitol building and the cowboy governor. *Courtesy of Paul Horsted Collection.*

Then the public was invited to roam the capitol and greet new officials in their offices. That evening, a Pennsylvania orchestra played for two thousand at a city auditorium dance. Governor and Mrs. Berry led a grand march. Also present were L.E. Corey, the candidate Berry defeated in the Democratic primary and now the new state finance director, and Dave McCullough, recovered from the Colton car crash and stepping into the state banking directorship.[53]

In his inaugural address, Berry reiterated his commitment to use the axe (at least eight axes were presented to him by citizen groups the week of the ceremony). "The people demand, and they are entitled to, the elimination and abolition of many activities of government," he said, "wherever that can be done without material loss of efficiency."[54] He successfully pushed for abolition of the state coal mine, hail insurance program and bonding department. The governor would ask the legislature to reduce its own membership, and across South Dakota state college presidents wondered if their schools might face Berry's axe. Berry sometimes told people that he never set foot in a college classroom yet did fine in life. During his time as governor, Berry made it clear that in education he preferred spending to boost public elementary and secondary education over funding colleges. If students weren't well prepared in public schools, he reasoned, there would be no need for colleges.

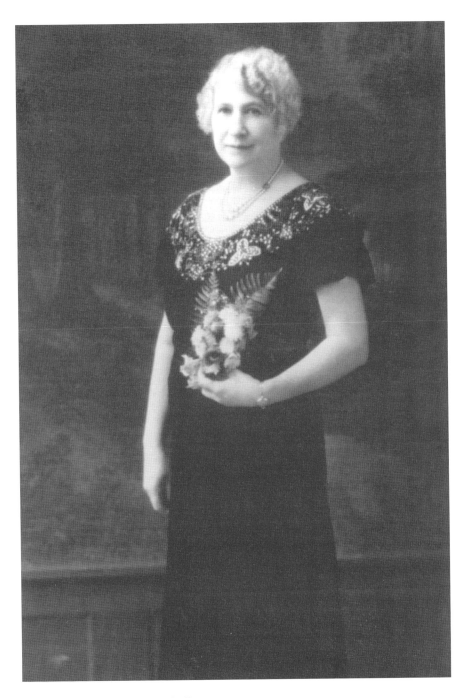

Rena Berry as First Lady. *Berry family.*

But one issue weighed most heavily on his mind that inauguration day: making interest payments on Rural Credit bonds due that month and again in April. About $750,000 was due in January, money the state simply did not have in its coffers. Failure to pay could severely damage South Dakota's credit rating and hamper its efforts to pull itself through the Depression on many fronts. "Whatever may have been the policy in times past," Berry said of the looming payment, "the time has now come when South Dakota must face the situation as it is and prepare to meet it."[55]

Berry believed he could secure a very short-term bank loan for $750,000 if he could demonstrate that the state had a solid plan for future interest payments and for paying down the principal. He successfully proposed dedicating half of the state's 4 percent gasoline tax toward Rural Credit payments; it was the first bill he signed into law. He also thought he could negotiate better bond interest rates with the help of the federal Reconstruction Finance Corporation—an institution with which Governor Green had no success. The whole situation reminded him how much he despised debt, but he paid the January interest with borrowed bank money and in March flew to Minneapolis to negotiate with the Reconstruction Finance Corporation. Joe Chapman, the manager there, could soon confirm what everyone in the South Dakota livestock industry knew: Tom Berry was a smart, tough businessman who understood financing thoroughly. He left Minneapolis with $3,845,000, repaid the $750,000 short-term loan and was ready for the April interest payment. He was still dealing with more loaned money than he preferred, but at a more manageable interest rate, and he had a means for cutting into the principal. He wouldn't see the Rural Credit debt retired during his time in Pierre, yet he would be credited for setting up a system for beginning to do so.[56] He gave much credit to Dave McCullough and was deeply grieved when he passed away suddenly just weeks later.

Having a Democratic legislature upstairs from his office didn't mean everyone worked in harmony. But reduction of state salaries and elimination of nonessential jobs went smoothly. At the end of 1933, the governor told the *Denver Post* that "during the first nine months of this year the payroll has been cut $226,000 as compared to a like period in 1932." That was, as he had hoped, about 10 percent of state payroll costs. In 1931, the legislature set a biennial budget of about $8 million, and in 1933, Berry and the legislature axed more than a quarter from that figure.[57] The legislature didn't shrink its membership. Farmers and ranchers, especially, applauded Berry's success in suspending the property tax, replaced with an income tax. That didn't seem bad if you made no income—the case for many in agriculture. But the

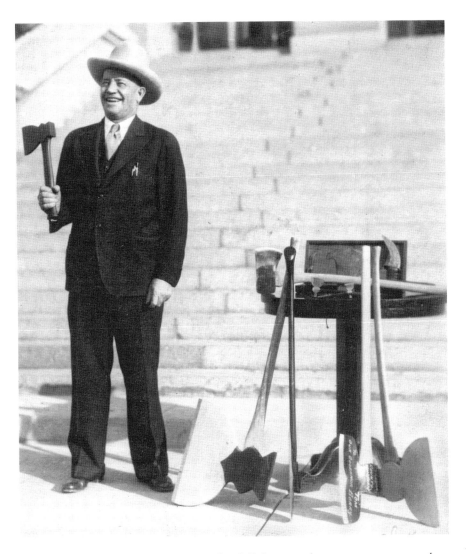

Individuals and organizations from across South Dakota sent the new governor axes, so he could cut waste from government as promised. *Berry family.*

governor and the legislature were sharply divided about whether the income tax should be based on gross earnings or net earnings. Berry thought gross earnings and prevailed. Lieutenant Governor Ustrud strongly preferred a tax on net earnings and was probably already thinking of challenging Berry for the Democratic gubernatorial nomination next election.

Two months after Berry took office, it was time for Franklin Roosevelt to assume the presidency. Roosevelt had turned to a friend he had in common

45

The first bill Governor Berry signed into law applied gasoline tax revenues to pay down the state's Rural Credit debt. *Courtesy of Paul Horsted Collection.*

with Berry, *Mitchell Daily Republic* publisher W.R. Ronald, as key advisor in developing agricultural components for his New Deal, soon to be unveiled. It's possible that Ronald first told Roosevelt about the astute, free-spirited man just elected South Dakota governor. Roosevelt experienced Berry's pointed wit firsthand when he wired the governor about help in finding a South Dakotan for a federal position—someone with a background in both banking and law would be ideal, the president noted. Berry replied he didn't know anyone that crooked.[58]

The president enjoyed and came to deeply admire Berry. He usually called him "Tom" or "Cowboy." The regard was mutual. At least once, Rena enjoyed lunch at the White House with a most gracious Eleanor Roosevelt.

Roosevelt's appointment of George Philip as United States attorney for South Dakota pleased the governor. Upon meeting Berry and Philip, it

would be easy to guess that the men had little in common. Philip came across as urbane, and he wore fine suits and glasses. He was a year younger than Berry and had come to South Dakota at about the same time, though from across the Atlantic. Philip was Scottish, and a bond he shared with Berry was their time as 1902 roundup cowboys. In 1903, Philip left the state for law school at the University of Michigan but was back in 1906 to set up law offices at Fort Pierre and Philip (a town just north of Mellette County named for his uncle, cattleman Scotty Philip). Berry appreciated George Philip's friendship, professional judgment, commitment to the Democratic Party and the fact that he could swap authentic cowboy stories equal to his own.[59]

Berry studied the flurry of federal laws passed in Washington as President Roosevelt spent his first one hundred days in office building a policy foundation for addressing the Depression. Americans joked about the litany of "alphabet soup" programs created—PWA, NRA, AAA, CCC and more. But in the governor's mind, it was a new language he had to learn if he hoped to attract federal resources for relief and reclamation. As Roosevelt's first one hundred days wound down, in June, he and Berry arranged a White

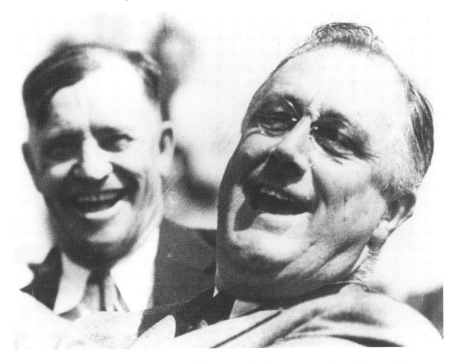

President Roosevelt appreciated Berry's humor and unique perspectives. The president often called him "Tom" or "Cowboy." *Berry family.*

House meeting. Berry stepped off a train at Washington's Union Station and into a wilting, muggy heat. "Hell, where's a water hole?" he asked anyone in earshot. A newspaperman told Washington readers, "Reporters who had been told Governor Berry looked and talked like Will Rogers were not disappointed. He had everything but the lariat."[60]

At the White House, Berry found Roosevelt attentive to all he said (including insight into the cattle industry), and he was impressed by the president's knowledge of South Dakota. They discussed ways conservation might restore Dust Bowl lands, and the governor predicted benefits from dams. What impressed Berry most about Roosevelt was his commitment to preventing human hunger. Hunger was omnipresent in Berry's state, where some families routinely counted their bites at every meal to make certain there would be food tomorrow.

It's not known whether Berry told Roosevelt that day about a plan he had for raising relief dollars in South Dakota: legalizing the manufacture and sale of beer as dismantling of prohibition laws began, and applying a special tax. There can be no doubt that the governor thought about the beer matter on his trip because of his ongoing conflicts with Lieutenant Governor Ustrud. Taking action on beer could be done only by the governor calling a special session of the legislature. Some legislators were urging Ustrud to call the session as acting governor while Berry was absent, allowing them to add other bills for consideration—including repeal of the new gross income tax that Ustrud found objectionable. Berry raced back home and prepared for a "beer-only" session, and he stressed to the public that the drink in question was "3.2 beer" as opposed to the intoxicating kind. The beer the governor advocated would contain less alcohol than "high-point" varieties, but as future generations of South Dakotans would attest, it could be fully intoxicating when consumed liberally.

The lieutenant governor and allies spoke out about addressing other matters in session, too. Berry reminded them that every day legislators worked in Pierre cost taxpayers $2,000 and that the beer bill was complex enough to demand everyone's full attention. A prohibition article in the state constitution was a hurdle.

The session convened July 31, and as it became apparent Democratic leaders were still open to adding new business, Berry called them into his office. When someone remarked that perhaps the governor hoped to keep the public's attention on beer alone because it would be "politically expedient," those in the room saw another side of "jovial Tom Berry"—a tough man unwilling to allow an ugly implication pass. "I don't give a

damn," he snarled, "about my political future. What I'm thinking about is to get some relief revenue from beer as quickly as possible." He also reminded lawmakers that he had veto power over other legislation they might pass, and no one doubted he was in a mood to apply that power.[61]

The 3.2 beer bill passed on August 4, and the Berry administration projected it would raise more than $1 million annually. Half of the tax revenue would be distributed to counties, with county commissioners deciding how to use the dollars for "relieving the destitute." The other half would be put to use for the same purpose statewide, under the governor's discretion.[62]

The swift, innovative way South Dakota put beer to work in advancing relief attracted attention in Washington. Berry received a letter of congratulations from Harry Hopkins, Roosevelt's federal relief administrator. Hopkins closed by saying, "I think you know you can count on us to cooperate with you fully in any of your relief problems in South Dakota."[63]

Among problems Berry reported to the Roosevelt administration were conditions American Indian people faced on reservations. Terrible as poverty and drought were across the state, things were still worse on South Dakota's reservations, producing myriad health problems.[64] Elsewhere, especially in eastern South Dakota, Berry was encouraged as farmers earned federal Agricultural Adjustment Administration (AAA) checks by leaving some fields unplowed, allowing the land to rehabilitate and slowing the glut of certain crops on the market. In early September, Berry returned to Washington. He carried with him photographs that illustrated the drought's impact on South Dakota lands. He had the president's attention, he knew, and intended to keep it.

The president studied the photos and issued a statement to the press:

> *Yesterday the governor of South Dakota came to my office with some extraordinary pictures of farmlands where grasshoppers had devoured everything down to the roots; where there isn't anything left for man or beast; where many thousands of farmers are faced not just with the temporary problem of being helped out a little here and a little there but with the fact that neither they nor their livestock have a chance of getting anything to live on until next summer. There is an emergency. We are going to try to take care of it as an emergency. It comes very close to the border line—where the Red Cross has not authority to step in because it is a peculiar kind of disaster and does not result from flood or fire.*[65]

Eventually, South Dakota would see about sixty-three thousand families on relief, the highest percentage of any state. Governor Berry himself would serve as the unpaid relief director for a year and encourage South Dakotans needing help to phone him collect. The collect calls added a couple hundred dollars per month to the governor's office phone bill.

Berry made certain South Dakota's young men had every opportunity to join what they usually called "the Cs," the Civilian Conservation Corps, or CCC, as the public generally called the program.

The CCC seemed to explode into existence. "I propose to create," Roosevelt said upon becoming president, "a Civilian Conservation Corps to be used to do simple work, not interfering with normal employment, and confining itself to forestry and the prevention of soil erosion, flood control, and similar projects." Just thirty-five days after Roosevelt's inauguration, the program was funded and ready to go, involving the states and the federal departments of War, Labor, Interior and Agriculture. At age seventeen, men could sign up, gain physical conditioning through the U.S. Army and be sent to camps where they would perform outdoor work for a dollar a day. Each month, twenty-five of those dollars would be mailed home.

Forty-eight camps were established across South Dakota. Nationally, about two-thirds of camps were located to benefit farm country, with the other third dedicated to natural lands, including national forests. In South Dakota, though, there was more emphasis on forestlands because under

CCC laborers built a fire trail through the Black Hills National Forest. *Black Hills National Forest Collection, Leland D. Case Library, Black Hills State University.*

Awaiting transportation to a work site, CCC men lined up. *Black Hills National Forest Collection, Leland D. Case Library, Black Hills State University.*

extreme drought conditions the Black Hills were in danger of burning. CCC men in twenty-eight Black Hills camps thinned pines and underbrush, built fire trails, fought fires when they erupted and used logs and stone to build public structures. Berry was successful in enhancing state parks with CCC labor, not a typical course of action elsewhere. On South Dakota's prairies, the emphasis was on preserving soils, building stock dams and planting long lines of trees to create shelter belts, protecting fields from soil-robbing winds.[66]

CCC labor truly transformed some South Dakota lands, and it left a deep impression on participants. For some, the camps were where they first joined a team comprising both white and minority men. For many, the army training and barracks life prepared them as soldiers who would shortly fight World War II.

Later, the Works Progress Administration (WPA) would put adults who lost their jobs or businesses back into the workforce, performing functions that benefited the public. Road and bridge work, as well as construction of airports that all towns hoped for in the 1930s, were among prominent projects South Dakotans came to associate with the WPA. Aligning South Dakota's accounting system with the federal government's expectations for CCC and WPA reports proved a never-ending headache for the

governor and his staff. Among Berry's most unpopular actions was his decision one harvest season that some WPA laborers leave the program temporarily and hire on with farmers to bring in crops. As it turned out, some farmers couldn't pay what they promised. Like the president and other governors, Berry heard complaints that too many WPA jobs were merely "make work," subsidized by taxes. Eventually, many critics came to agree that projects had value, made a real different across South Dakota and weren't likely to be taken on by free enterprise as well as that it was better for laborers to leave their homes daily rather than just collect relief checks.[67]

Governor Berry believed in Roosevelt's programs and, before the year was out, learned how completely the president himself believed in them. Roosevelt stayed true to the course of action he'd set through a crisis that directly involved Berry and other midwestern and Great Plains governors.

Milo Reno was a man very much on Governor Berry's mind in the fall of 1933. Reno wasn't a South Dakota constituent but rather an Iowa man, the national leader of the Farm Holiday Association. His group, comprising mainly farmers across the Midwest, announced that perhaps 2 million members were prepared to pay no taxes or debts and boycott sales and purchases until the federal government agreed to guarantee farmers prices for produce that equaled cost of production. Reno used wheat, a South Dakota farm staple, to illustrate the producers' plight. That fall, a bushel of wheat brought farmers $0.75 but, Reno claimed, averaged $1.35 per bushel to produce. Producers of other crops and livestock faced similar disparities. So, Reno announced, their goods were unavailable until the problem was resolved. Farmers who betrayed the Farm Holiday Association effort and crossed picket lines on their way to sell produce or animals could expect trouble, Reno said.[68] No one doubted him. A man transporting milk had been shot and killed near Jefferson, South Dakota, during a Farm Holiday strike earlier in 1933,[69] and now violence made headlines in Iowa and Wisconsin especially. In Minnesota, farmers discussed forming their own militias to enforce boycotts and break up farm foreclosure sales. Sympathetic army veterans offered to train them.

North Dakota governor William Langer called on Governor Berry to join him in a demonstration of support for farmers. Langer announced an embargo on wheat leaving his state by rail and added that he was prepared to use the state militia to stop trains. Governor Berry declined to do the

same, as did all other governors. Railroad attorneys had argued effectively that under the Interstate Commerce Act rail companies were obliged to transport whatever citizens wanted to move.

In November, Iowa governor Clyde Herring invited Berry, Langer and the governors of Minnesota and Wisconsin to join him in a meeting with Reno at the Iowa capitol building. Reno would tell his picketers to stand down if the five governors could convince President Roosevelt to advance farm recovery at the same rate as other industries covered by the National Recovery Administration (NRA). True, farmers had Roosevelt's Agricultural Adjustment Administration (AAA) working for them, but Reno believed that the AAA should be disbanded and its services made part of the NRA, where they would be more nationally prominent. At the very least, these services would no longer be under the auspices of Henry Wallace, Roosevelt's secretary of agriculture, if Reno had his way. The governors knew Reno's contempt for the secretary. "Wallace's education and association with Wall Street have made him what he is today," Reno said. "Wallace would make a second-rate county agent if he knew a little more."[70]

In the Iowa meeting, Reno outlined his idea for bringing farmers under the NRA umbrella and said that his association believed Roosevelt should announce a national moratorium on farm foreclosures and immediately find a way to guarantee cost of production prices. The five governors said they would go immediately to Washington but would focus solely on cost of production. Three days later, they arrived as a group at the White House. "South Dakota's Tom Berry, a broad-brimmed plush hat of sandy hue above his leathery face, took the steps in a rolling cow-boy gait," *TIME* magazine observed.[71]

The governors made their case for federal cost of production guarantees in a meeting Roosevelt and Wallace both attended. The president and Wallace seemed far from enthusiastic. Where could such a vast volume of money come from? As if to underscore desperate matters in the Midwest, dispatches to Wisconsin governor Albert Schmedeman during the meeting told him that angry farmers were on the move in his state, threatening to bomb milk and cheese plants. The governors left the White House that day feeling like they had made no progress, but they were scheduled to return the next day.

This second meeting was with Wallace alone after the secretary discussed options with Roosevelt. Wallace told the governors the president considered the proposed guaranteed prices far too high. The governors huddled and said they were willing to reduce guarantees by 20 percent, and that's where

the second day ended. By the third day, Roosevelt had concluded that cost of production guarantees would increase the price consumers paid for affected goods by about 70 percent—completely unacceptable. The best course for farmers, he told the governors, was to leverage all they could get from the Agricultural Adjustment Administration and to understand that as National Recovery Administration programs moved into high gear, urban consumers would have more income and food prices could rise in the free market. "To enforce the immediate adoption of such a price," Roosevelt told the press, "in view of the inability of city consumers to take present quantities of farm products at such a price, the governors advocated compulsory control of marketing." He wasn't willing to take that step.[72]

Berry and colleagues left Washington feeling defeated. Milo Reno expressed outrage, telling reporters, "Never again will we call this strike off until our demands are met." (Wisconsin's Schmedeman had to wonder if it had really been called off in the first place.) The Midwest braced itself for an explosion. South Dakota was mostly quiet, but just across the border, farmers burned a railroad trestle near Sioux City, Iowa. Elsewhere, railroad engineers reported shots fired at their trains.[73]

But then the revolt simply faded away. Year-end AAA subsidy checks arrived in the mail. It turned out that plenty of farmers had earned subsidies by supporting the administration's effort to reduce the nation's glut of farm produce and livestock. In 1933, farmers had left some fields untilled, although many complained that they didn't know they could earn subsidies that way until their crops had been planted. Culling animals, by contrast, knew no season. *Time* magazine described the subsidy checks as "descending on the land in a gentle, pervasive rain, dampening the prairie fire of farmers' anger." Secretary Wallace made a speaking tour through the heartland in late fall. Somewhat to his surprise, he was met with cheers instead of boos. Of course, the farm emergency of the 1930s was far from over. Some families would flee the land, and some would know desperate hunger. But the fact that five governors were willing to aggressively advocate in Washington for drastic action, combined with the positive first steps of the short-lived Agricultural Adjustment Administration, somewhat negated frequent claims that the farmer was America's "forgotten man."[74]

Meanwhile, faculty at South Dakota's state colleges felt somewhat forgotten. Their institutions struggled with the governor's 40 percent

funding reduction for higher education, and many were concerned about Berry's boast that he had done fine in life without setting foot on a college campus. As the husband of a teacher who had succeeded admirably with just a high school diploma herself, Berry saw no need for requiring that state certified teachers hold four-year college degrees. That was the trend nationally, and South Dakota colleges had made considerable success in moving South Dakota toward that standard.

Berry's family recalled that tension between the governor and higher education was evident when a delegation of professors came to Pierre to meet with Berry. The professors said they were content with their salaries—they weren't asking for a raise. That was good, Berry noted, because he considered them overpaid as it was. The professors had a proposal, however, that they considered modest. Currently they and their colleagues were paid monthly for nine months. Couldn't the state divide annual pay—the same pay—into twelve monthly installments, making employees' personal budgeting easier? Berry was incredulous, telling them that college faculty could certainly put a little effort into personal budgeting and tuck away money in January for anticipated expenses in July. They should look to farmers and ranchers, he said, who typically had one payday per year—if at all.[75]

In the era of the biennial South Dakota legislature, there would be no legislative session in 1934. It was an election year, and politics heated up early. Looking ahead, Berry suggested that if reelected he would use his clout in Washington to obtain federal funds for two east–west paved highways across the state. One Republican leader commented that the governor's popularity was prompting some Republicans who hoped someday to become the state's chief executive to sit out the 1934 race. But Berry didn't have to look far to find an opponent. Lieutenant Governor Ustrud announced in February that he would challenge Berry for the Democratic nomination. Ustrud made repeal of the gross income tax his central issue, and he had the backing of the left-leaning South Dakota Farmers Union. Berry declined to debate Ustrud, said that he'd let his record speak for itself and added that he wouldn't campaign on the road much during primary season. He was always open to reporters, though. About the United States deciding to officially recognize the Soviet Union, Berry observed, "We have some trouble with Russian thistles. Maybe we can do something about them now that it's all right to recognize them."[76]

One day in Pierre, outside the St. Charles Hotel just down the street from the capitol, a neighborhood dog bit the governor. Apparently, the dog didn't recognize Berry, who had left his usual western hat at home and was wearing

a straw hat. Berry told the press the dog was obviously Republican, but he forgave him because a man wearing a straw hat "should be bitten."[77]

That kind of sunny press attention annoyed political opponents, including Ustrud, who said he believed South Dakotans were tiring of Berry's Will Rogers act. But the governor was making hard news, too, showing himself as a tough law-and-order man in February, when an armed mob removed a tenant from a farm near Sisseton and reinstated a farmer previously evicted during a foreclosure. Seventeen mob members were jailed in Sisseton for weeks, unable to post bonds ranging from $500 to $2,000. A law enforcement official, R.D. Mintener, reported that a crowd he called "particularly ugly and surly" milled around the courthouse and jail, and a rumor circulated that three thousand militant North Dakota farmers planned to storm Sisseton and liberate the prisoners. "We have undertaken this investigation," Mintener told reporters, "and the subsequent proceedings, including the arrest of leaders, with the distinct understanding from Governor Tom Berry that he will support our stand in the full capacity of his power, which means with state military forces if need be." The North Dakotans never invaded South Dakota, but in 1934 it didn't seem far-fetched.[78]

More intimidating than armed farmers in 1934 were great dust storms, or "black blizzards." Winds tore topsoil away so dirt filled the air and then drove the dust across the plains. Lorna Buntrock Herseth, decades later South Dakota's first lady and then its secretary of state, remembered times when travel was dangerous both day and night. "There was so much earth moving in the sky that visibility was down to zero," she wrote. She recalled fences buried under dust and "huge black holes eroded in the fields."[79]

In May, Berry defeated Ustrud in the primary by more than thirty-five thousand votes. The same day, W.C. Allen, publisher of an Aberdeen farm newspaper, secured the Republican nomination for governor. The political rhetoric slowed as a dry summer played out. Berry announced that through the Agricultural Adjustment Administration, ranchers who couldn't feed "distressed" cattle could sell them to the federal government. Purchase would start in the driest sections of the state—a little difficult to determine by that point in the drought. Actually, much of the federal payment for cattle went to banks that had loaned ranchers money for the livestock. That resulted in complaints from hungry ranch families, but banks were on legal footing and claimed that losses from cattle loans would jeopardize the institutions and money entrusted by depositors. Meanwhile, Berry and Senator Bulow pushed successfully for some of the purchased cattle to be transported live to South Dakota reservations. The cattle would be slaughtered there and could

A black blizzard raged across South Dakota. *National Park Service, FDR Library.*

feed native populations through the winter if properly preserved. Berry told Washington officials he knew exactly how some of the meat would be preserved: by drying it and turning it into jerky—a most effective method, he thought.[80] Beginning on June 28, a total of twenty-five thousand cattle was delivered to state reservations. By that point, about fifty thousand head of cattle had been shipped to slaughter out of state and many others euthanized and buried on site because they were so emaciated.[81]

Berry heard complaints from some fellow ranchers who said the federal government didn't appreciate the caliber of certain animals it bought. These cattle represented many generations of careful breeding and carried blood lines of great value yet were viewed by purchasing agents as just standard cows available for a uniform price. As an accomplished cattle breeder himself, the governor could only say he understood, but there was no negotiating prices with a government responding to an emergency, not entering the cattle business. Selling off cattle wasn't being forced on anyone, he added.[82]

Another touchy issue was playing out just west of Berry's ranch in an area he knew as the White River Badlands. There was land there that the federal government determined to be "sub-marginal." South Dakotans had developed true ingenuity for squeezing agricultural profits from marginal lands—poor soil, limited water—but sub-marginal was an entirely different category. The Badlands became a true desert in the 1930s. In Washington, D.C., the idea of kindly buying up Badlands properties may have seemed like pure mercy, but to many South Dakotans, the action felt like insult added to injury. "Sub-marginal" designation seemed like an official, public proclamation that someone had been foolish in ever attempting to work the land. In 1929, President Coolidge, at Senator Norbeck's urging, had set wheels in motion for creating an eventual Badlands National Monument, showcasing bleak yet spectacular beauty and recalling pioneering fossil research done there.[83] Badlands residents of the 1930s who sold their land to

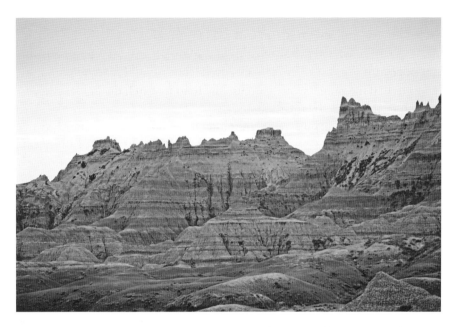

Tom and Rena developed their Double X ranch east of the White River badlands, later known as Badlands National Park. *Ryan Phillips.*

the federal Resettlement Administration knew the property would certainly become part of the future park. They could easily imagine tourists someday snapping pictures and shaking their heads, wondering how anyone ever believed this could be home.

Pioneering photography showing the curvature of the earth was shot through the portholes of a balloon gondola launched from South Dakota during Governor Berry's tenure. He and Rena took great interest in the project, a joint venture of the United States Army and National Geographic Society, with assistance from South Dakota School of Mines engineers. The nation took interest, too. In fact, live national radio coverage of the flight would later be considered a precursor to how TV and radio networks would cover manned space flights nearly thirty years later.

The launch site was an alpine bowl in the Black Hills, with a vertical descent of 450 feet. The balloon, when filled with gas, would stand 350 feet high. "There are few places in the world where it is safe to inflate such huge bags," wrote Albert Stevens, flight commander, "for they tower into the air until they encounter strong air currents unless protected by a wall such as

that of the natural bowl at Rapid City."[84] The spot was promptly dubbed the Stratosphere Bowl, later shortened to Stratobowl. Berry visited the site and authorized improved road access for trucks that would haul equipment in. If he guessed the public would also use the road to watch the launch, he was correct. People came by the thousands.

The mission's purpose was announced as scientific, from exposing fungi spores to cosmic rays to photographic observations. But there can be no doubt that the element of human adventure fueled the public's fascination. The adventure was dangerous. In 1933, three Russians, in a similar gondola with a look-alike balloon, reached an altitude of perhaps thirteen miles. They were killed after something went wrong and the gondola plunged to earth.

In July 1934, as the state's first lady, Rena was invited to dedicate the gondola. The ceremony in the bowl was broadcast to millions over NBC radio. "And probably every one of you wishes that he could have an active part in the flight," she told the nation. "I did, and it has become my good fortune officially to name the gondola—the great black and white ball that is here before me—in which Major Kepner and Captain Stevens will be lifted many miles above the earth. I would like for each of you to feel that I am acting as your representative in this ceremony whether you live in the East, the South, the North, or the West of our beloved country....This ship of the air which I am about to name is going on a journey of exploration—a journey to push into new regions and learn new facts. No man has ever before been where this ship will go. No man knows exactly what it may find. It sails off, manned by a gallant crew, to discover what it can and so I name it Explorer."[85]

Rena's speech turned out to be the highlight of 1934 for the Stratobowl project. Days later, Stevens, William Kepner and Orville Anderson took

Captain Albert Stevens and wife posed with Rena and Governor Berry, 1934, at the gondola dedication. *Minnilusa Pioneer Museum.*

off and drifted south (the mission was entirely about vertical ascent—no one cared where the balloon moved horizontally). Eleven miles above Holdredge, Nebraska, the bag ripped. A hydrogen and oxygen mix escaped and then burst into flames. Like the Russians the year before, the three Americans felt themselves plummeting earthward. Horrified Nebraskans saw the burning balloon streak through the sky and assumed the worst. But half a mile over the plains, the men jumped and parachuted to safety. The gondola Rena dedicated smashed into the ground, but a National Geographic flag aboard was salvaged and presented to Governor and Mrs. Berry.[86]

In the fall, Berry campaigned for reelection on the road. A drive east from Pierre to Miller kicked things off. In Miller, Berry stressed his success in reducing the cost of state government, eliminating "useless branches" of government, addressing Rural Credit indebtedness and bringing federal relief dollars to South Dakota. Again he mentioned plans for paving highways across the state, using federal dollars. He got his audience laughing with this line: "I don't think I'm asking too much when I ask you to give me a lieutenant governor. You know I never had one." Berry's running mate in 1934 was Robert Peterson.[87]

Both candidates for governor had surrogates who stumped aggressively for them. For Berry, it was Senator Bulow, stressing how the governor had brought $37 million to South Dakota from New Deal programs. And Bulow addressed a rumor, what he termed "a whispering campaign," that claimed Berry drank to excess. "If Berry gets all the votes of men and women of South Dakota who drink more liquor than he does," Bulow asserted, "he will win by a hundred thousand majority."[88]

On the Republican side, Charles Alseth of Lake Preston stood up for candidate Allen, who had defeated Alseth in the Republican primary. He charged that Governor Berry most certainly didn't act as state relief director for free, that he was drawing a second salary that was hidden somewhere in relief records. In October, Alseth said that Berry's big campaign crowds could be attributed to CCC men hauled in on government trucks, men who were "hazed or bulldogged or enticed" to participate. At Menno, Alseth said, "Under dictatorships in Italy and Germany the people are given to understand that it will be healthy for them to get out and cheer when their ruler speaks, and very unhealthy if they don't, but this is the first time these tactics have been tried in South Dakota."[89]

Berry countered that Allen had no real platform. Not too subtly, Democrats stressed the governor's close connections to the president by releasing an October letter Roosevelt mailed, gently scolding Berry. "Dear Tom Berry," the letter read, "Your kind message regarding the radio talk of September 30th and its reception in South Dakota was deeply appreciated. Why must I wait to hear from you until I make a radio address? You know of my interest in South Dakota generally and my desire to keep currently posted. Let me hear from you more frequently and please do not be guided in this by any radio or other schedule of mine. Very sincerely yours, Franklin D. Roosevelt."[90]

W.C. Allen suddenly found himself in hot water for remarks made after visiting Martin, a town between the Rosebud and Pine Ridge Reservations. Republican Clement Valandra, member of the board of advisors for the Rosebud Council, was furious over Allen's description of native children scampering to Allen's airplane like "insects" drawn to a sugar bowl and by his reference to encountering "two big buck Indians." In a letter to the *Sioux Falls Argus Leader*, Valandra addressed Allen: "[T]o be frank with you and my Republican friends of South Dakota…you need not depend on the Indians and his dogs for your support as we are all for the man who is for us as well as our white neighbors."[91]

Actually, Allen wasn't finding much support anywhere. On election day, Berry won the reservations. He won Sioux Falls easily, especially gratifying

A crowd gathered to hear Tom Berry in Mobridge. *Berry family.*

61

because he didn't come close to winning South Dakota's biggest city in 1932. Overall, Berry was reelected governor by a margin of about fifty thousand votes. Democrats retained control of the legislature and claimed every state constitutional office in Pierre.[92]

A few days after winning reelection, Berry was in Hollywood, California, cruising onto the Fox movie lot in a sleek, twelve-cylinder Cadillac. He had come to visit cowboy humorist Will Rogers, who complimented Berry on the car. "Oh, this isn't our car—we rented it," Berry said. "Do you think I could have been elected governor of South Dakota with a car like this?"[93]

Berry and Rogers had never met before, but the internationally famous entertainer knew about the South Dakota governor. For more than a year, the national press had noted striking similarities between the two—both born on the plains in 1879; "disciplined on the saddle," as one paper put it; and with same "careless mop of hair," speech patterns, grin and choice of headwear. Their philosophies and quips ran parallel, too. Long before Berry made a name for himself in politics, South Dakotans would sometimes ask if he knew Rogers or consciously patterned himself after him. No, he answered. Now in Hollywood, Rogers stated the obvious. "Tom, if you ain't my double, I never had one," he observed.

Rogers, an Oklahoman by birth, worked as a cowboy. Then he discovered he could make good money in Wild West shows and vaudeville. Before audiences he spun a lariat with incredible prowess and always chewed gum as he drawled his way through stories, with a sly grin revealing that a punch line was approaching—or had just passed over listeners' heads. He went on to host a radio program, write a newspaper column and act in movies. Whatever the medium, politicians and American government were favorite targets for his humor. From Theodore Roosevelt to Franklin Roosevelt, most politicians enjoyed the jokes, even when turned on them. But not three-time presidential candidate Williams Jennings Bryan of Nebraska.

"I am a humorous writer," Rogers explained to Bryan during an encounter. Bryan replied, "I am a serious politician."

"Maybe we are both wrong," surmised Rogers.[94]

President Calvin Coolidge, ever stoic in expression, frequently made his way into Rogers's stories. After a visit to Egypt, Rogers said, "I was the only tourist there who never went out to see the sphinx—well, I've seen Calvin Coolidge."[95]

Tom Berry and Will Rogers met in Hollywood, November 1934. *Berry family.*

The day after the 1932 election that swept Berry and other Democrats into office across the country, Rogers wrote, "It looks like the only thing that can beat the Democrats is honest counting." He was, himself, a Democrat who prided himself in skewering both political parties equally.[96]

There can be no doubt that Berry was invited to speak at conventions and dinners—including ones outside South Dakota—because organizers guessed they'd get a little dose of Will Rogers along with anything else the governor might say. The pressure to perform in that way never seemed to worry Berry, and his audiences were seldom disappointed. The trip to California in November 1934 came about because U.S. Marshal George Robertson of South Dakota had to pick up a prisoner. He was to transport him back to South Dakota as a witness in a kidnapping trial. The governor, who had never visited California, said he would like to come along and help. In Los Angeles, Robertson and Berry's car developed a problem requiring a mechanic, and the men decided that touring Los Angeles in a Cadillac was the way to go.

Rogers joked that Berry being escorted by a U.S. marshal reminded him of Louisiana governor Huey Long's heavy-handed security. "I do this to keep Marshal Robertson from arresting some of my friends while I'm away from South Dakota," Berry replied.

That day, Rogers was filming a politically themed movie, *The County Chairman*. His visitors got to see some scenes shot, but mostly Berry and Rogers talked for three hours. They joked, discussed Indian customs and recounted their days on the range.[97]

Rogers offered, "If you boys will stay over until tomorrow, I will show you the biggest ranch in the city of Los Angeles." Berry thanked him but said they had business to attend. The two men had made a personal connection and exchanged Christmas greetings a few weeks later. "I don't know what it is," Rogers wired, "but I'm trusting you Merry X-mas." He declined an invitation to Berry's second inauguration, asking the governor, "Can you imagine a man going to Dakota this time of year without being taken by a sheriff?"[98]

The fact that the Democratic sweep was a repeat from just two years earlier didn't dampen the enthusiasm for another big inauguration in Pierre in January. In 1935, 2,500 people tried to cram into the city auditorium for a grand march that didn't happen because the building was too crowded, as well as for a dance. In his second inaugural address,

Governor Berry reminded South Dakota that "federal relief will not last always and neither will the hell of drought and insect plague continue forever."

He added that the 1930s hadn't changed the character of South Dakotans. "Just as soon as we get a normal year," he said, "when the rains come and the grasshopper is no longer a burden, no one will more quickly, nor more cheerfully, withdraw from federal and all other public relief than the independent South Dakotan."[99]

The legislative session began immediately, with two key issues: legalizing alcohol beyond just 3.2 beer and wines to end prohibition completely and increasing state tax revenues. As the liquor bill took form, it allowed for private enterprise sales or, if a city preferred, municipal liquor stores. A state commission would hold all licensing and taxing authority, with cities approving those licenses and determining what types of business could sell by the drink.[100] Berry signed the bill into law and appointed Joe Ryan executive officer of the state liquor commission. Ryan was the Iowa newspaperman shaken up in Berry's 1932 car crash. He had moved to South Dakota and served the governor and state Democratic Party in several capacities before accepting the liquor commission job.

As for increasing state tax revenues, most Democrats in the South Dakota House and Senate favored repealing the gross income tax. They supported a net income tax, which, every formula suggested, would generate considerably less revenue. Berry said, as the legislative session began, that he would try to let law makers work independently from him. Still, on the gross income tax matter, he visited the House chamber and argued that the tax had to stay intact. It was repealed, however, and a net income tax instituted, combined with a 2 percent state sales tax. Berry decided the combined "net-sales" tax formula could work and signed it into law.[101] But the 1935 legislature, and Governor Berry, would long be remembered for another tax, entirely new to South Dakota: gold income levy.

In one of his early acts as president, Franklin Roosevelt was successful in taking the United States off the gold standard. It was part of the Emergency Banking Act, aimed to infuse more value into currency. Ramifications were huge in South Dakota, the nation's number one gold-producing state and home to the country's biggest and most technically advanced gold mine: Homestake in the Black Hills. Under the new law, the federal government would purchase gold at a guaranteed price, $35 per troy ounce. Homestake Gold Mine was a publicly traded corporation

with offices in San Francisco, and almost immediately its shares rose in value to $430, eight times their previous value. It was hard to find another American corporation weathering the 1930s better than Homestake. A question was raised that had occasionally been asked before: why wasn't South Dakota applying any tax whatsoever to gold shipped out of state by a California company? "Tax Gold, Not Poverty" proclaimed posters and literature produced by the South Dakota Farmers Union, ready to lobby in Pierre and armed with figures about farmers in danger of losing their lands and livelihoods because they couldn't pay their bills in the Depression and Dust Bowl era.[102]

Homestake was among gold claims staked during the 1875–76 Black Hills Gold Rush. In those years, the region was part of a reservation, off-limits to nonnative settlement by federal treaty. But gold seekers swarmed into the Black Hills in such numbers that the U.S. Army said it couldn't stop them. Because the nation was struggling through an economic depression in the 1870s, it is possible the government didn't want to stop prospectors. A major gold strike could revive the economy, and if that was the hope of leaders in Washington, they hit a jackpot.

Brothers Fred and Moses Manuel along with partner Hank Harney staked the Homestake claim a mile above sea level in the northern Black Hills, where the town of Lead would spring up. But what set their mine apart from all others was the arrival of George Hearst, founder of the vast Hearst fortune and a U.S. senator from California. He believed that Homestake could blossom beyond all expectations if he invested in ever-advancing technology, top engineers and far-sighted company leadership. He bought Homestake in 1877 for $70,000, incorporated the company in 1878 and had it listed on the New York Stock Exchange by 1879.[103] It would produce gold until 2001 and provide well-paying employment for thousands of South Dakotans.

In fact, during Tom Berry's entire lifetime, South Dakotans saw Homestake as something of an alternative universe in their own backyard. It stood immune to agricultural price fluctuations and to weather extremes that workers above ground faced. It drew an international workforce that made Lead a cosmopolitan community unlike any other in the state, advanced industrial technologies nationally and by the Berry administration was safely dropping miners 3,500 vertical feet below Lead. Soon Berry and other state leaders would get an ear-full about how expensive the mining infrastructure was, as well as how foolish they were if they thought Homestake was a golden goose that couldn't be killed.

There were always Homestake miners who had left the life of hardscrabble South Dakota farming and believed they had found something better for themselves and their families in the Black Hills. When they heard Farmers Union members complaining about poverty, some were inclined to ask, "What did you expect on the prairie?" Farmers Union speakers didn't always find friendly audiences in the Black Hills. East River farmers Emil Loriks and Oscar Fosheim, from Oldham and Howard, respectively, were leaders in both the Farmers Union and South Dakota legislature, and in both arenas they spoke frequently and passionately about South Dakota's need for a gold tax. They earned the nickname the "Gold Dust Twins." Both were Democrats considered much more liberal than Governor Berry. For them and fellow Farmers Union members, the tax issue became more compelling after Homestake benefited by Roosevelt's action. Berry knew a gold tax would surely come out of the 1935 legislative session. If the bill failed, Farmers Union members were successfully circulating a petition that would bring the matter to a public vote in 1936 as an initiated measure. When Loriks was elected state Farmers Union president in 1934, he decided to leave the legislature to devote all his energy to union business. That meant one less guaranteed pro-tax vote in the state Senate but also an aggressive lobbyist who would spend virtually all his time during the 1935 session fighting for a gold tax.[104]

Governor Berry, in his 1935 inaugural address, said that allowing any industry to escape payment of "its share of public burden is manifestly unfair."[105] Beyond that, during the session he had little to say about gold and made no funny quips about roping Californians and making them earn their keep in South Dakota. It's likely, given the Farmers Union fervor, that he thought a bill might emerge that taxed gold at such a high rate that he couldn't in good conscience sign it. Indeed, when the House of Representatives produced a bill that would apply a 10 percent tax, Berry made it known he considered that unreasonable and that he hoped to see something better come out of the Senate.

Homestake, meanwhile, vigorously pleaded its case, appealing directly to South Dakota citizens. If they thought a Homestake tax was really a tax on one of America's wealthiest families, the company said, they needed to understand that the Hearsts had been out of the corporation for a generation. Most likely to be hurt by a tax, Homestake claimed, were retired miners and their widows who relied on company pensions. At a time when the need for "old age pensions," including a proposed Social Security system, was very much on Americans' minds, Homestake's argument found some support.

SOUTH DAKOTA'S COWBOY GOVERNOR TOM BERRY

The Gold Dust Twins pushed on undeterred. Everything came to a head during an eighteen-hour conference during which legislators merged sections of House and Senate bills to propose a law establishing a 4 percent tax rate. The bill passed both legislative houses, and Berry signed it.[106] To both supporters and detractors of the gold tax, Berry would always be remembered as the governor who made it happen. Homestake certainly never credited him for steps that likely saved it from a much steeper tax rate. From 1935 on, Berry knew he could count on Homestake as an adversary when he ran for office. So could Loriks and Fosheim, if they had aspirations for higher political office—and it turned out they did.

The tax yielded $750,000 its first year. The governor who succeeded Berry would sign a law that increased the tax to 6 percent. Homestake swung into action and created a public relations department, perhaps the best ever developed by a private company in state history, and effectively described the mine's expensive infrastructure and the company's value to South Dakota. Decades later, this department boasted how it got the state through the Depression and Dust Bowl years, sometimes supplying a quarter or more of all state tax revenue.

During the Depression, all forty-eight state governors had to consider how to handle violence that might arise when struggling industries downsized and faced angry workers trying to feed their families. For Berry, the hypothetical situation became actual on March 9, 1935. That day, the governor received word that an unusual "sit-down strike" was underway at the big John Morrell meatpacking plant at Sioux Falls. This was a new form of strike, all but unheard of anywhere else previously, and it was playing out in an industry key to Sioux Falls' economy. Opened in 1909, the Morrell plant grew so that by the 1930s it could slaughter up to five thousand hogs and five hundred cattle daily, meaning jobs for 1,700 men and women. But now, with less livestock being produced and fewer families able to afford good cuts of meat daily, plant production fell. Some workers got only eight to twelve hours on the job weekly. Morrell implemented layoffs, and employees complained that the layoffs seemed arbitrary, with no consideration of seniority. A group of workers decided to form a union to negotiate, and Morrell announced that it would not negotiate with a union. The company knew who the union organizers were and in early spring laid off or fired twenty-nine of them.[107]

What made the sit-down strike unique was that workers didn't initially set up a picket line. They showed up as usual March 9 and reported to their

Morrell meat packers crossed a picket line in Sioux Falls, 1935. *Siouxland Heritage Museums.*

work stations. Then, at midmorning, key personnel stopped working and sat down. Union leader Sam Twedell told the plant superintendent that no more work would be done until management agreed to bargain and that no one wanted to see meat spoil so he hoped management would respond quickly. No word from management came, however. Tons of meat were ruined, and a big part of the workforce remained in the plant through the day and night and into the early morning hours of March 10.

Governor Berry phoned the plant at 4:00 a.m. and spoke with Twedell. Fearing the situation would escalate into violence, Berry had called in National Guard units from Brookings, Madison and Vermillion. He headquartered them in the city coliseum, just up the road from Morrell. Both the governor and Twedell knew that as long as the plant was occupied, with meat rotting, it was a powder keg. Twedell agreed to lead his followers out of the plant and set up a picket line outside if Berry called off the National Guard.[108] Berry did so but had to bring them back briefly two days later when violence broke out. He requested that United States Attorney George Philip, the old cowboy friend from roundup days, meet with Morrell officials and Twedell's union.[109] That happened, but simultaneously, the company was trying hard to organize

workers who didn't like the union. Led by plant foremen, non-union men charged the picket line and beat one picketer severely with a pipe yet didn't succeed in ending the picket demonstration. The company secured police protection that got men who wanted to work into the plant, as well as animals for slaughter. Operations resumed, in part because replacement workers were easy to recruit when so many were desperate for employment.

In July, Morrell made an aggressive push to get strikers off the property. Union and non-union men, and most likely some hired strike-breakers, clashed in a full-scale riot. About five hundred men fought, and more than fifty went to the hospital. The riot made big headlines and, more than any other development, won the union public support. Nationally, buyers began boycotting Morrell products. The strike continued for two years. Twedell believed the buyers' boycott was the reason the company finally agreed to recognize the union as a bargaining agent. The strikers, including the twenty-nine original organizers, returned to work if they wished. The union later won employees hospitalization, insurance, vacation and retirement benefits. When economic and agricultural conditions improved, Morrell came back strong as a South Dakota industrial force. As an ally of a pro-labor president, Governor Berry would sometimes be criticized for not backing the union more. Just as often, though, he was credited for signaling that the state would facilitate high-level discussions between parties, as well as for his commitment to public safety.[110]

In April 1935, Governor Berry returned to Washington to look into more New Deal opportunities. People he met there were hearing good news from South Dakota—spring snows and rains were putting moisture into the ground. Could it be the end of the great drought? (It wasn't.)

The governor dropped by the Department of Agriculture and reminded bureaucrats how they bought up South Dakota livestock in 1934. "Now, you know, we've been getting lots of rain and snow," he said, "and we've come down here, now that we haven't any livestock, to see if you won't stock us up with fish."[111]

More seriously, there and in other departments, Berry discussed highway funding, federal relief for distressed public school districts, expanded CCC work and shelter belts. In Washington, the governor conferred with John Collier, Roosevelt's commissioner of Indian affairs.

Like Berry, Collier loved discussing American Indians' traditional cultures, something he hadn't been exposed to until age thirty-six, when he spent a

Governor Berry encouraged development of shelter belts to limit soil erosion by wind. *Ryan Phillips.*

year in New Mexico. Collier, born in Atlanta and educated at Columbia University, was a sociologist. In the Roosevelt administration, he argued that forcing cultural assimilation on reservations destroyed something of value, and he advocated for a "New Deal for Indians" and the Indian Reorganization Act of 1934. The act reversed an 1887 federal law that removed lands from communal tribal control and allotted property to individual tribe members. Under that policy, South Dakota cattlemen arranged reservation grazing leases with individuals, sometimes coming to know them well. The 1934 act meant that leases would be obtained through a process involving tribal government. If that brought a lot of bureaucracy into play, in a way that was Collier's point: the Indian Reorganization Act emphasized strong government on each reservation. Tribes wrote constitutions modeled after the United States and individual state constitutions.

Collier's critics said that's where flaws showed in his understanding of American Indians. His critics believed tribes to be more culturally diverse than Collier knew. They asserted that with the federal government out of the way, some tribes might devise forms of governing that did not resemble the United States Constitution. Few people, though, questioned Collier's genuine

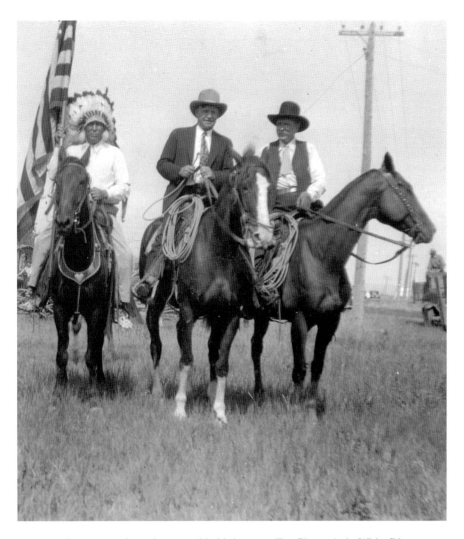

Governor Berry opened a rodeo named in his honor at Fort Pierre. As in White River, showcasing Lakota culture was part of the show. *Berry family.*

concern for native peoples. In Berry, Collier knew, he'd met a kindred spirit. That day in Washington, the two men discussed grazing leases, an issue very much on the minds of South Dakota cattlemen, the governor included. Collier said that nothing would change in the immediate future, that leasing reforms would be phased in gradually. Building solid units of government on South Dakota reservations would be the first order of business.[112]

Drought was again in full evidence as spring segued into summer. During those months, Governor Berry spoke about the need for South Dakotans to plant trees and promised a Watertown audience that he would not challenge Senator Bulow for the Democratic nomination for U.S. Senate in 1936.[113] The governor feuded with *Sioux Falls Argus Leader* correspondent Ralph Hillgren about the writer's claim that Berry had exaggerated federal relief dollars coming into South Dakota.[114] In July, the Stratobowl crew was back, preparing for a launch with a gondola called Explorer II, but a rip in the balloon (detected on the ground) delayed takeoff by months.

Another adventure in the sky gained national attention in August. Will Rogers joined pilot Wiley Post for a 'round-the-world adventure. Rogers would share observations with regular dispatches to newspapers. The pair flew first from Seattle to Alaska, where Rogers met "emigrants" from the forty-eight states determined to farm in the vast northern territory. He wrote, "There is a lot of difference in pioneering for gold and pioneering for spinach."[115]

Those were the last words Rogers wrote for publication. On August 16, near Barrow, Alaska, the plane crashed. Both Rogers and Post died. Immediately upon hearing the news, many fans recalled what Rogers said five years earlier: "When I die, my epitaph or whatever you call those signs on gravestones, is going to read, 'I joked about every prominent man of my time, but I never met a man I didn't like.'"[116]

Reached for comment by the Associated Press, Berry said, "For a great many years I have admired Rogers' homely philosophy and his rare sense of humor. This admiration only increased after I met him and we became close personal friends."[117]

Novelist Rupert Hughes eulogized Rogers, saying, "God send us some successor to Will Rogers, because we need someone to keep us laughing, as we must save our dignity." The press syndicate that distributed Rogers's daily newspaper quips, to publications reaching 40 million readers, hoped for a successor, too. In less than a week, it decided Berry might fit the bill if he had time as a sitting governor. Berry said he was willing to give it a try. He disliked typewriters but would jot comments about current events in pencil and then find someone who would type the dispatch. Like Rogers, he would be brief, writing just seventy-five words or so, allowing papers to squeeze the piece into a front-page corner or some other prominent spot. Also like Rogers, the Berry column would be written in what one news writer termed "the vernacular of the range"—replete with "ain'ts," "fellers," "'ems" and "figgereds."

"A cowboy humorist with a careless mop of hair, an infectious grin and sympathies as broad as his 30,000 acre ranch, stood out today as the man who may carry on the beloved role of Will Rogers," the United Press reported on August 23. "He is Tom Berry, homely, unsophisticated governor of South Dakota. No man more closely resembles the character of the great Rogers."[118]

On an international issue, Berry wrote, "See where the diplomats are holding another naval limitation conference in London. Wonder who'll come home with the biggest navy this time." As fascism in Italy threatened other parts of Europe, less than twenty years after the world war, Berry opined, "Kinder looks to me that after 200 years we ought to admit Washington was right about mixing no politics with Europe. I'm just a cowboy but I never let the same hoss kick me twice in the same place."

Of a slight controversy about the Texas governor appointing too many honorary colonels, Berry "figgered Kentucky had a state monopoly on this colonel business, but it seems I'm wrong…as long as these appointments don't mean anything, I think I'll make a few myself but I'm going to go Kentucky and Texas one better. I'm going to appoint my fellers generals."

He became the only South Dakota governor ever to take a humorous jab at the artistic integrity of Mount Rushmore, then a work in progress in the Black Hills under sculptor Gutzon Borglum's direction. The sculptor announced he was preparing to focus his efforts on the granite presidents' collars and hair. "Looks to me," Berry wrote, "like it's a little early to start worrying about clothes. You can't hardly tell the boys apart yet. As far as their hair is concerned, I'm in favor of just turning it loose."[119]

But being a columnist, Berry told a reporter after a few months, "isn't all it's cracked up to be." He was weighing the possibility of attempting something no other South Dakotan had achieved: winning a third term as governor. If he ran in 1936, a year that would also see President Roosevelt up

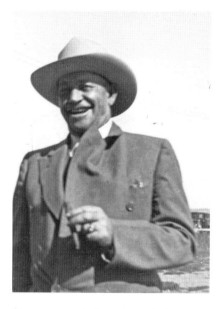

The governor dedicated an aviation hangar in Watertown, September 1935. *Berry family.*

Explorer II launched successfully on November 11, 1935. *Black Hills National Forest Collection, Leland D. Case Library, Black Hills State University.*

for reelection, Berry would give up his column and focus his attention on what would certainly be an intense race. The idea of a third term would be viewed as overreach by some South Dakotans.

Before the political season commenced, though, there was a big nonpartisan event for South Dakotans to share in 1935. The Stratobowl project would attempt a cold weather launch on November 11, and past problems didn't dampen NBC Radio's enthusiasm. If anything, the flaming crash of 1934 heightened the national press's fascination. The flight crew was reduced to two—Albert Stevens and Orville Anderson—and they wore protective headgear in the form of leather Rapid City High School football helmets. Helium would fill the balloon, with no combustible hydrogen involved, and the new gondola, Explorer II, was made of a lightweight magnesium alloy. The metal was soon to be used universally in aircraft construction.

With the 1935 flight scheduled during the school year, millions of American children spent the day listening with their teachers to NBC's coverage. In South Dakota, some students were successful in convincing their teachers to allow them to go outside and scan the sky for a glimpse of the balloon. Explorer II took off at 7:01 a.m. and drifted east this time, over the White River and land where Tom and Rena had trailed cattle twenty-two years before. The gondola rose 13.7 miles above the earth, an altitude record for manned flight that stood for twenty years. In *National Geographic* magazine a few weeks later, Stevens wrote from that altitude "no sign of actual life on earth could be detected…we were almost completely divorced from Mother Earth."[120] The balloon sailed across the Missouri River and over East River countryside. After eight hours and thirteen minutes aloft, it touched down gently near the town of White Lake. Fifty CCC men raced to the landing site to guard against souvenir hunters who might shred the balloon. A crowd of three thousand reached the scene to stare at a piece of aviation history—and did no damage.

The state's Federal Writers' Project launched thirteen days before Explorer II. In documenting the flight, project writers found a uniquely rural way to describe the balloon's size: "2-2/3 acres of cloth." As a consummate storyteller, it was no surprise that Governor Berry took interest in this WPA program that would put writers to work recording South Dakota's diverse range of tales and historical perspectives. The Federal Writers' Project was funded at a level to allow authors to work every corner of the state. Most importantly, perhaps, was the opportunity to collect stories of native peoples,

accounts that had historically been passed orally and were at risk of being lost as use of native languages diminished. In Washington, Harry Hopkins considered the writings produced "a portrait of America—its history, folklore, scenery, cultural backgrounds, social and economic trends, and racial factors."[121]

Berry wanted in. The writings could certainly benefit South Dakotans, schoolchildren included, and enhance tourism. The Federal Writers' Project began just as South Dakota subjects and writers were winning national audiences as never before. Most significant in the 1930s were the prairie pioneer memories of Laura Ingalls Wilder, published in the *Saturday Evening Post* and later in her classic *Little House* books, some of which played out in the East River town of DeSmet. A West River author who also appeared in the *Saturday Evening Post*, Archer Gilfillan, wrote stories and observations somewhat aligned with Berry's worldview, but with one key difference: Berry was a cattleman and Gilfillan a sheepherder. Historically, there had been sharp tensions between cattle and sheep producers on the plains, but as the twentieth century progressed, many South Dakota ranchers ran both forms of livestock in separate pastures. In 1929, *Atlantic Monthly* published Gilfillan's informative, humorous book, *Sheep*, a national hit that was reprinted through the 1930s and beyond. It offered vivid descriptions of West River landscapes and weather and aimed humorous barbs at cowboys. A cowboy minus his hat and spurs and chaps, Gilfillan wrote, could be distinguished from a hired man only with the services of "a whole detective agency."[122]

Archer Gilfillan would be a key part of South Dakota's Federal Writers' Project, but Berry needed a project director. Lisle Reese, a twenty-five-year-old freelance newspaper and magazine writer who grew up in the Aberdeen area, was interested—and Berry was interested in him. A fellow journalist, along with Reese's barber, said they knew why the governor thought Reese a good choice. His columns could sometimes be caustic, and his friends theorized that putting him into state service would preempt any biting wit directed at Berry. Reese went to the state capitol to see the governor, "whose beguiling smile indicated he had just roped an ornery steer," Reese recalled. Berry told him he appreciated his writing style and suggested Reese take the job part time, up to twelve days per month, so he could continue his freelance work. The first order of business would be publication of *A South Dakota Guide*, a travel book, so an office at the Pierre railroad depot seemed appropriate.

Reese had to recruit a team of authors, and because the WPA was a relief program, they had to be unemployed. Finding out-of-work writers proved

no problem. Gilfillan, for example, had a book in national circulation, but Reese found him in Deadwood living off tips as a cave guide. Applicants with strong writing backgrounds but no job included former teachers, a librarian, an attorney who had lost his speech and hearing and a former priest. Writing was produced and mailed to Federal Writers' Project headquarters in Washington, D.C., where staff didn't always understand or appreciate South Dakota culture. Of the "World's Only Corn Palace" in Mitchell, a Washington editor insisted cutting "world's only," he said, "because no other city would probably want one!" Mount Rushmore proclaimed as the shrine to Democracy? Word came back from Washington: "Delete—This is not a shrine to anything."

Still, work progressed. When the text and illustrations were complete, the Washington office told Reese it couldn't arrange dollars or an in-kind contribution for printing (in some regions, major publishing houses assumed the risk) because there weren't enough South Dakota bookstores for distribution. Eventually, the South Dakota legislature appropriated funding to produce an initial run of four thousand books. *A South Dakota Guide* was well received, but the Federal Writers' Project nationally fell on hard times. In Congress, the project was investigated by the House Un-American Activities Committee on charges it was infiltrated by communists in New York and Massachusetts. Washington leaders were fired or resigned.

In South Dakota, however, the program blossomed, evolving into the South Dakota Writers' Program, sponsored by the University of South Dakota under Reese's direction. A remarkable range of books and booklets were published, including *Legends of the Mighty Sioux*, with illustrations by Lakota artist Oscar Howe. The work became a staple in South Dakota libraries and schools and at shops where out-of-state visitors looked for souvenirs beyond ashtrays and trinkets. Read today, it may feel a bit heavy with platitudes or morals that conform to European tradition, but in its time, it represented an honest appreciation of native culture and was an attempt at what South Dakotans later termed "cultural reconciliation." The writing produced in South Dakota with government aid stands as one of Governor Berry's major legacies, supported by Democrats and Republicans alike at various stages.[123]

In January 1936, the U.S. Supreme Court ruled the Agricultural Adjustment Act unconstitutional, saying farm policy should be a state matter and expressing disfavor of food processors collecting tax dollars that benefited

their suppliers. Berry quipped, "[E]ven if she wasn't constitutional, she sure did a lot of good while she lasted." With a nod to livestock culled as part of AAA policy, he added that "the country was made safe for the little pigs."[124] Parts of the AAA survived after the authorizing legislation was rewritten in Washington.

For Tom Berry, the summer of 1936 was a mix of stepping into the national spotlight at Philadelphia, fighting grasshoppers and hosting the president of the United States. All the while, he would be working to capture a third term as governor.

First, though, came the business of trailing 890 steers from the Berry ranch to summer pasture forty miles south. Son Baxter Berry ran the ranch now, and the senior Berry would show up only as a cowhand for a few days. Paul, who had a ranch nearby, would also ride, along with a handful of other hands and Burrell Phipps, who had married Nell. When John Bailey, editor of the *Aberdeen American News*, volunteered to mount up and help, too, the governor said sure and drove him to the ranch. Along the way, the governor pointed out landmarks like Trunk Butte and Deadman's Gulch, where, Berry recalled, two men engaged in a fatal dispute over water rights. At the ranch, Berry climbed onto his horse, Jug, and found another for Bailey, and the two rode off to catch up with other riders and the herd. Within fifteen minutes, they met the day's first challenge, killing a nine-button rattlesnake. Nine cowboys, including the governor and Bailey, pushed the steers south, and they also pulled a chuck wagon over the rugged prairie. "Never did the smell of brewing coffee and frying ham so intrigue the olfactory senses," recalled Bailey of that evening's camp.

Baxter gave orders for night watch. The governor was assigned the shift from 8:40 p.m. to 10:40 p.m. "After regaling us with stories of 'Lousy Joe' and other characters who followed the roundups of yesteryear, the governor donned his sheep coat and chaps and departed to his night trick," wrote Bailey. Later, Berry bedded down in a tent to the howls of a distant coyote and was up four hours later, before 3:00 a.m., to strike camp and eat breakfast. The day turned hot, making the animals sluggish, but the herd was grazing in the south pasture by nightfall. The next morning, the governor and Bailey rendezvoused with a car for a ride back to the ranch house. "Seems I haven't been away at all," Berry said during the drive, looking across the landscape of drought-affected grasses. But at the house, a barrage of phone calls reminded him that he had. "Long distance from Pierre! Long distance from Sioux Falls!" wrote Bailey.[125]

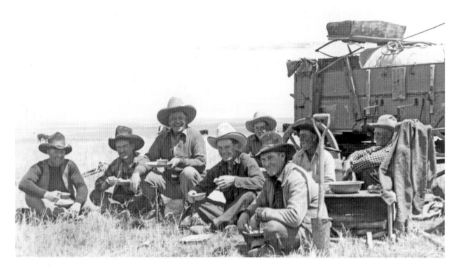

A chuckwagon was still used on the Double X ranch in the 1930s as cattle were moved to distant ranges. *Berry family.*

By the time of the cattle drive, Berry knew that he was the Democratic candidate for governor that fall without a primary challenge. Also running in November, if things went as Berry hoped at the Democrats' national convention in Philadelphia, would be President Roosevelt. By no means was Roosevelt's re-nomination to be uncontested, as Berry's was in South Dakota. "Al Smith Democrats" claimed that Roosevelt's bold policies were too extreme for many Americans. They hoped to see Smith, Democratic nominee for president in 1928, nominated again in 1936.

It would be a big year for plains states in national politics—John Nance "Cactus Jack" Garner from Texas seemed likely to be re-nominated as Roosevelt's vice president, and current Kansas governor Alf Landon won the Republican nomination for president.

A national reporter asked Berry how things were going in South Dakota that year. "I told him the state was filling up with people moving in from Kansas," deadpanned the governor.[126]

Berry traveled to the East Coast in late June with two goals: push vigorously for Roosevelt's re-nomination at the Democratic convention and go to Washington to report to the Department of Agriculture about a new challenge South Dakotans faced. Hordes of voracious grasshoppers, unusually big, were eating whatever plant life the parched plains could

produce and even gnawing into hardwood products no one had imagined an insect would attack.

Some 1,100 Democratic delegates filled Philadelphia's Bellevue Stratford Hotel and the city's nearby convention center on June 23–27. Despite mild fears among Roosevelt's people about a party revolt, it became clear early on that the convention would mostly play out as a demonstration of affection and loyalty for the president. At one point, however, Al Smith Democrats perched in the hall's gallery and unfurled Smith banners, drawing boos and eventually Roosevelt supporters who climbed up, seized the banners and bloodied some noses. Some present believed that the brief pro-Smith rally came in response to remarks at the podium by a Sioux Falls man, Frank Wickhem. As national president of Young Democrats clubs, Wickhem predicted that "over three million young men and women will support the New Deal this year" and proclaimed that club members wanted to serve, not move against, the party's national committee in support of Roosevelt.[127]

No South Dakotan, though, attracted more attention than Tom Berry. He was as much at home in Philadelphia as he had ever been attending a Rapid City convention of South Dakota Stock Growers. He greeted everyone, posed for photos smiling broadly, waved his hat and yelled his approval when Roosevelt supporters addressed the convention. He and fellow delegates endorsed a party platform that favored Social Security, fair pricing for consumers, rural electrification, quality housing and extended civil service. Then came the business of formally nominating Franklin Roosevelt. The party's national committee had decided that a favorite son from all forty-eight states plus nine non-voting territories would each second the nomination, a process that dragged on for hours. To no one's surprise, Governor Berry was the South Dakotan asked by the committee to make a seconding speech. He said, in part, "if it hadn't been for the relief that has been sent in to South Dakota the people couldn't have stayed there. Millions of dollars have gone there and been distributed among the poor and the needy who have spent it all in the State of South Dakota, and it has gone to the merchants and the business men and the bankers to keep their doors open."

He concluded, "If it hadn't been for the man who is President of the United States, the greatest man I think who ever sat in that Chair, a man with a heart of gold, who will not let anybody starve or go hungry, I don't know what we would have done, and I as a governor of a Western prairie state want to second his nomination, and I am proud to do it, and my people are

proud that I second the nomination of Franklin D. Roosevelt, the greatest living man today!"[128]

It was a strong speech, although there's doubt how many people heard it. As the hours wore on, a constant din of celebration rose from the floor. But Berry's big moment that night was yet to come.

By 11:00 p.m., President Roosevelt's nomination was scheduled to be wrapped up but wasn't. The convention chairman urged the few remaining second-nominators to shorten their orations. West Virginia Senator Matthew Neely responded

Berry at the podium in Philadelphia, 1936 Democratic National Convention. *Berry family.*

with a full-length speech. Finally, the parade of speeches ended, but there was still the business of a state-by-state roll call for calculating Roosevelt's nomination tally. At 12:41 a.m., Berry rose, walked to the podium and in a booming voice honed hollering commands to cowboys on the plains said, "Mr. Chairman, I move that the rules be suspended and Honorable Franklin Delano Roosevelt be declared the nominee for president of the United States, by acclamation!"[129]

He got no argument. Delegates shouted their approval for Roosevelt, the session adjourned and by 1:00 a.m. the convention hall was mostly empty. The next day, in relatively subdued fashion, the party re-nominated Cactus Jack Garner. That evening, the convention moved to massive Franklin Field, where President Roosevelt addressed 100,000 people as he accepted the 1936 nomination.

"The royalists of economic order," he said, "have conceded that political freedom was the business of the government, but they have maintained that economic slavery was nobody's business.... [W]e are poor indeed if this nation cannot afford to lift from every recess of American life the dread fear of the unemployed that they are not needed in the world."

Berry and others who supported New Deal policies knew that they would be called to answer in 1936 for any program deficiencies their political opponents might find. Roosevelt reminded them, "Better the occasional faults of a government that lives in a spirit of charity than the consistent omissions of a government frozen in the ice of its own indifference."[130]

With that speech, the convention wrapped up, and Berry was off to Washington for meetings. Then he returned to South Dakota and faced two strange requests. Leslie Jensen, his Republican opponent in the governor's race, noted that Berry claimed to have no time for a debate yet made time to attend rodeos and salute the crowd from a pony. "If he prefers to debate on his pony," Jensen told the press, "I'll meet him, mounted and in full regalia."[131]

Berry declined. Next came a request from the White House. President Roosevelt was wondering if Berry could organize an outdoor church service, Protestant, in the Black Hills. The president would attend in August and so could the public.[132]

The governor knew the president planned to tour the Great Plains in late summer to see drought-stricken lands firsthand, talk to farmers and learn how reclamation projects were progressing. As it developed, Roosevelt also accepted an invitation from Mount Rushmore sculptor Gutzon Borglum to dedicate the great face of Thomas Jefferson, nearing completion that summer. Borglum scheduled the event for a Sunday, and it would draw thousands and receive national radio coverage. The dedication would involve pulling a big American flag from the face, and the sculptor stressed that it had to happen at noon, when the sun's angle was just right. The president planned to stay in Rapid City Saturday night and knew he couldn't attend church Sunday morning and make it to Mount Rushmore, over still primitive roads, by noon. A public church service amid the pines, he decided, was just the ticket.

In late August, Berry and Senator Bulow met the president in Oakes, North Dakota, where he was wrapping up his tour of that state. They climbed aboard his train, dubbed by the press the "Dust Bowl Special." The train crossed into South Dakota, and Roosevelt and the two South Dakotans talked. The president noted they constituted a club of three governors—two from South Dakota and he, the former New York governor. "No," insisted Berry with a grin. "We have just one governor in South Dakota and I'm it!"[133]

The Dust Bowl Special's first South Dakota stop was Aberdeen, where police estimated a crowd at the rail station to be thirty-five to forty thousand strong—the biggest in Aberdeen history. A motorcade moved the president, Berry, Bulow, Secretary of Agriculture Henry Wallace, other members of the president's party and the press corps into the countryside. They talked to farmers encouraged by a heavy rain the night before. West of Aberdeen, Roosevelt saw the new $88,000 Richmond Dam, designed to flood more than a thousand acres when rains came back fully, and emblematic of dams

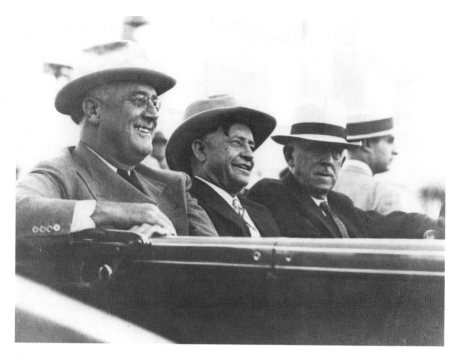

Roosevelt, Berry and Bulow, a club of governors in Roosevelt's thinking, toured South Dakota by train and open automobile. *Historic Black Hills Studios Collection.*

and irrigation systems that Berry told the president would one day help crop and livestock producers alike.[134]

In addresses across South Dakota, Roosevelt, often speaking extemporaneously, called the governor "my old friend" and emphasized addressing agricultural problems scientifically. He stressed that $1 million spent now could create long-term solutions that would yield many millions in coming years.

In Redfield, Berry and Roosevelt spoke briefly from the train's rear platform. Now the president called all South Dakotans "my friends," and the governor said Roosevelt meant it. "I'll say it again," said the president right on cue. "My friends!" Roosevelt cited Redfield as the home of his Republican friend Senator Norbeck. Meanwhile, Berry and Bulow exited the train so they could race ahead by car and greet the president formally as he arrived in the capital city. They missed a frightening moment as the train began moving away from the station and a man ran alongside and reached for Roosevelt, still on the car's platform. Apparently, the man only hoped to

Greeting the crowd in Pierre from the Dust Bowl Special, *left to right*: Governor Berry, Senator Bulow, President Roosevelt and Roosevelt's son, John. *Courtesy of Paul Horsted Collection.*

shake hands, but the Secret Service feared an attack and pushed Roosevelt inside the car.[135]

In Pierre, another friendly crowd welcomed Roosevelt. He and Berry spent most of a Saturday with Secretary Wallace, discussing Dust Bowl recovery, and they were joined by Wyoming governor Leslie Miller. Late in the day, Roosevelt, Berry and the party boarded the train again, bound for Rapid City. They crossed the Missouri River and for nearly two hundred miles journeyed through rolling, treeless prairie—Tom Berry country. It's unlikely the president made the journey without the governor pointing out landmarks and telling tales. Berry could relax. The tour was going well. An East River reporter had written, "Cheerful throngs along the way contrasted with the dismal appearance of the cropless fields." The governor had known for a good while that he didn't have to organize a church service, after all. Roosevelt decided he wanted to worship at Rapid City's Emmanuel Episcopal Church.[136] Upon arrival Saturday night, the party took rooms at the Hotel Alex Johnson, within view of the location where Calvin Coolidge had his temporary presidential offices and four blocks from Roosevelt's church of choice.

Up in the Black Hills, sculptor Gutzon Borglum was perhaps the unhappiest man in South Dakota that Saturday. He had received word the president would come to Mount Rushmore after church, at least a couple hours after optimal light on the Jefferson figure. The president was free to visit the mountain as he pleased, Borglum replied, but if he wasn't there by noon the dedication would happen without him.

Mount Rushmore, although destined to become South Dakota's most recognized landmark and leading tourism destination, proved a challenge for governors and state legislators during its fourteen years of development. First proposed by state historian Doane Robinson in the mid-1920s, it attracted no support from Carl Gunderson, governor at the time. Governors Bulow and Green were friendlier to the concept and people backing it, but they and legislators sensed public apathy, especially in East River. The sculpture, perpetually short on funds, never won an appropriation from the state legislature. Carving moved forward mainly because Senator Norbeck loved the idea, got President Coolidge enthused during his 1927 Black Hills residency and won Congressional funding with U.S. Representative William Williamson's help on the House side.

By the time Berry was governor, the George Washington head was fully recognizable and pulling in more than 100,000 visitors annually, despite Dust Bowl conditions across South Dakota and surrounding

The president and party stayed at Rapid City's distinctive Hotel Alex Johnson. *Ryan Phillips.*

Roosevelt attended services at Emmanuel Episcopal Church instead of worshipping in the forest. *Ryan Phillips*

regions. When Berry served on the Custer State Park Board, there was some thinking that Mount Rushmore might be annexed into the park. But the National Park Service took control the first year of Berry's governorship. That suited most state leaders fine. Sculptor Borglum was a genius but also fiercely independent. He bristled at any attempt to control his work or budget. Sometimes it seemed that Senator Norbeck was the only South Dakotan he listened to, and of course, Norbeck had plenty of other matters requiring his attention in Washington. For the Park Service to step in and bear the brunt of battles with Borglum seemed most generous.[137]

That Sunday in 1936, Roosevelt, Berry and Bulow arrived at the mountain by open car at 2:30 p.m., two and a half hours after Borglum's scheduled dedication. They found the flag draped over Jefferson's head and a crowd of three thousand awaiting them. Borglum, far from being angry now, greeted the president and governor warmly and set the unveiling into motion. Dynamite blasts punctuated the ceremony. The head came into view as the flag was pulled away, the crowd cheered and the president spoke. He hadn't planned to speak, but now, remaining in the car, he leaned toward a microphone and said, "I had no conception, until about ten minutes ago, not only of its magnitude, but of its permanent beauty and of its permanent importance." He predicted future generations would gaze at the carved faces of American icons and "will believe we have honestly striven in every day and generation to preserve for our descendents a decent land to live in, and a decent form of government to operate under."[138]

Roosevelt, Berry and Borglum gazed upward at the sculpture as photographers focused on the trio and clicked their shutters. Senator Norbeck was in attendance but didn't speak because cancer in his mouth made it difficult. Representative Williamson, a Republican from the same southwestern section of the state as Berry, did talk. Williamson was universally held in high esteem among cattlemen because of how he aggressively prosecuted rustlers while previously serving as a judge. But Berry and Williamson were far apart in thinking when it came to Roosevelt and the New Deal. Now Williamson told reporters he found the Rushmore crowd's response to the president lukewarm, probably because they'd had enough of the New Deal.[139] Time would tell. The 1936 general election was two months away.

Berry and Roosevelt attended the unveiling of Gutzon Borglum's Thomas Jefferson sculpture. *Ryan Phillips.*

Work on the Mount Rushmore figures progressed during Berry's terms as governor. He once joked about the granite presidents in his syndicated newspaper column. *Ryan Phillips.*

South Dakotans knew Les Jensen, Berry's opponent in 1936, as a successful businessman, president of a Black Hills telephone company. He had been an army officer during the world war (and would serve again for four years as a colonel in the next world war). He also had experience in the state legislature and working within the federal bureaucracy. It was an impressive résumé for the forty-two-year-old Hot Springs man, whose campaign stressed tough fiscal efficiency.[140] An up-and-coming Republican, Chan Gurney, challenged Senator Bulow and promised to "keep politics out of relief." The message seemed to resonate among South Dakota Republicans and helped all of the party's candidates, Jensen included.

During the campaign, Berry spoke of his own fiscal efficiency, stating that South Dakota's treasury had more than $9 million in actual cash on hand compared to four years earlier. He noted that state debt had been reduced by $6.6 million and that no taxes had been levied against anyone's property. Berry also stressed his commitment to state aid in funding public schools.

More than anything, though, Berry reminded South Dakotans that he could go to Washington, D.C., and come home with federal dollars South Dakota needed. Speaking to an overflow crowd at Webster's opera house, he recalled how early in his first term "men and women came into my office and broke down and cried" because they could not feed their families. In 1936, he continued, sixty-three thousand South Dakota families were on relief—about half of all families—and those dollars kept their hometowns alive. "We are all on relief directly or indirectly," he added.

A nagging embarrassment throughout the campaign was the construction of a new governor's mansion in the works at Pierre, a house Berry never considered a state priority. He claimed Harry Hopkins, in Roosevelt's administration, said the federal government would come up with materials for the home if South Dakota provided labor. "I said, I don't know, Harry," Berry told the Webster audience. "The legislature isn't in session, but if you will build us a house, I'll furnish the door knobs—and darn if he didn't take me up, and we will soon have a fine new governor's mansion that will not cost the people of the state a nickel."

He joked that he believed Jensen's desire to live in a spanking-new house inspired his candidacy. Berry mentioned how every section of the state hoped for oil-surfaced roads and that Jensen promised U.S. Highway 18 would be the first his administration improved in that way. "And he told them in Philip that 14 would be the first," Berry said, "and he told them in Mobridge that he would oil 12 first."[141]

The question as to whether any South Dakotan should break tradition and extend his governorship to a third term always loomed over the campaign. An editorial cartoon circulated showing Berry at a lunch counter with two pieces of pie not completely eaten and the governor ordering a third slice. The waitress said, "Say you've had two and all you did was mess them up. What would you do with another one?"[142]

Republicans charged Berry with abuse of power in office. They claimed that twenty-one state Department of Justice vehicles were sent to guard his fields during a rash of hay theft. Berry countered that the department had dispatched a total of three cars to patrol several counties during the crisis. An old charge resurfaced: that Berry directed construction of a CCC dam on Black Pipe Creek that benefited his ranch. That charge drew the ire of the Belvidere Commercial Club, which issued a statement, referring to "erroneous and apparently malicious statements" that were politically motivated. In fact, the statement added, the idea for the dam originated with Belvidere and Norris business leaders, "not with the idea of providing water for ranches, as that section of the country is well watered by springs, but with a thought of getting an artificial lake…as a game preserve and recreation center." Far from providing water for Berry's cows, the commercial club stressed, the dam actually diverted it into the lake."[143]

Most serious of the charges aimed at Berry that fall were those that hinted he served as state relief director because that put him in a position to skim personal profits from the program. Nothing ever surfaced to suggest that actually happened, and eighty years later, the accusation still angered Berry family members.

The election saw Roosevelt returned to the White House by a landslide, capturing all but eight electoral votes nationally, including South Dakota's. William Bulow edged Chan Gurney to retain his Senate seat. But Governor Berry lost to Jensen by ten thousand votes. Hard to figure, some South Dakotans said, except that state voters traditionally limited governors to two terms. But voters also returned a Republican majority to the legislature, clearly indicating a preference for Republicans in Pierre that would continue for decades.

No one who knew Tom Berry doubted he hoped to follow the footsteps of other South Dakota governors who were his contemporaries—Norbeck, McMaster and Bulow—and someday serve as a U.S. senator. Serving soon, with President Roosevelt still in office, was certainly appealing. Suddenly an opportunity to step into the Senate immediately presented itself in December when Berry had two weeks left as governor. Peter Norbeck, senator for nearly

Seeking an unprecedented third term as South Dakota governor raised some eyebrows and triggered this unfriendly political cartoon. *South Dakota State Historical Society Archives.*

sixteen years, had been battling cancer for a long while. No one, though, expected the end to come as quickly as it did. On December 20, in Redfield, Norbeck died of heart failure at age sixty-six.[144]

The senator died the day before the state legislature convened in special session, called by Berry, to enact unemployment insurance legislation. The

issue was complex, likely to trigger ugly political squabbles. Now, in addition to the session, Berry had to quickly appoint someone to complete Norbeck's third term through 1938, bringing about a first for South Dakota: both U.S. Senate seats filled by Democrats. He could have arranged to take the position himself. The best way to do that was to resign the governorship with the understanding that Lieutenant Governor Peterson, upon becoming governor, would appoint Berry to the Senate. Some Pierre insiders noted that Berry and Peterson were feuding (Berry's relations with his lieutenant governors seemed to range from chilly to hotly hostile), and there was no guarantee Peterson would make the appointment. Peterson, what's more, had just been arrested for embezzlement (in business, not government), and appointing a possible felon to the governorship certainly wasn't advisable. Berry also recognized that entering the Senate just weeks after sustaining a loss in a statewide election would be wrong.

For that reason, the *Sioux Falls Argus Leader* commended Berry for not seizing the Senate post. Instead he appointed Herbert Hitchcock, who assumed office on December 29. A Mitchell attorney by profession, Hitchcock had served in the state legislature and as chairman of the Democratic State Executive Committee. The governor knew him well. They shared similar views, especially about agricultural policies, and supported the New Deal.[145] It's likely Berry considered something else about Hitchcock that December. He was sixty-nine years old, the oldest South Dakotan to enter the Senate. Hitchcock would be seventy-one when the next Senate election rolled around, and an argument could be made that he was too old to seek a six-year term. In other words, he could serve as a well-qualified placeholder in the Senate, providing the Democrats time to settle on a well-qualified, younger candidate who could win the 1938 election and maybe that of 1944, too. E.H. Bremer, a capable man who served as Berry's secretary through his governorship, moved to Washington to become Senator Hitchcock's secretary. It's possible Bremer was among the first to sense, at some point, that his new boss liked the Senate, didn't intend to be anyone's placeholder and would run for election in his own right.

On New Year's Eve, Sioux Falls was rocked by a mighty explosion that broke windows across the city and in towns beyond. Was it the Farm Holiday Association announcing a resurgence of action in the new year or some other act of Depression-era industrial sabotage? To the relief of both outgoing and incoming state officials, the blast proved nothing more than an ill-conceived crime committed by a gang of jewel thieves. The gang determined two of its members to be disloyal and decided

that blowing them up in a powder house packed with dynamite and black powder would serve them right—and leave no evidence. The blast demolished the powder house and left a deep crater, but incredibly, one of the intended victims survived to tell the story in court.[146]

A few days later, the state's attention shifted back to Pierre, where the 1937 legislature convened and Les Jensen became governor. Outgoing governors usually addressed the new legislature before leaving town. Berry never saw much point in that but spoke briefly. "I know the members of the legislature as well as our new governor, Governor Jensen, are of a different political complexion from myself," he said. "I don't feel I should go before this body today and tell you how to run the government....I am for all of you, and for South Dakota...and now go ahead and do the best that you can, and I am sure that the people of South Dakota will appreciate your work, and I'm sure the people are in good hands."[147]

Jensen would serve a single term. In that brief period, much of his work involved setting up South Dakota's system for administering one of President Roosevelt's key programs, Social Security; improving roads; and eradicating rattlesnakes. Berry returned to his ranch but found opportunities to gently jab the man who had once challenged him to a debate mounted on ponies. Visiting Pierre one day, Berry decided to drop by the capitol for a chat with his successor. "Don't jump," said Berry, stepping into the governor's office. "I just came by to see if everything's still here."[148]

One night, Berry checked into a hotel, glanced at the guest ledger and noticed that Governor Jensen was staying there, too. Jensen had signed in as "Leslie Jensen and chauffeur." Berry scrawled, "Tom Berry and suitcase."

Chapter 4
SENATE RUNS AND COWBOY REUNIONS

The press, both nationally and in South Dakota, put big meaning into a chance encounter in August 1937. Berry went to Washington as a private citizen and attended a function where President Roosevelt spotted him. The president smiled and shouted, "Hello, cowboy!" Even out of public life, South Dakota newspaper editors wrote, it seemed Berry was still Roosevelt's man in South Dakota. The *Chamberlain Leader* observed that "any man who has no greater distinction than having been governor of South Dakota, who can go to Washington and get recognition of the administration from the President down, must have the personality that a lot of us haven't got." The *Watertown Public Opinion* noted, "Berry, according to the general understanding across the state, is to be the Democratic Party's next candidate for the U.S. Senate."[149]

At no point was Berry shy about his hopes for returning to public life, but he could be sly in revealing exactly what his intentions were. For example, he showed up in Sioux Falls and joked, "How long do you have to be here before you can run for mayor?" He added, "I've got politics in my blood now and life on the ranch is pretty dull after you hear people all over the state say, 'A penny for Tom.'"[150] He referenced what merchants across the state had said as they added sales tax to retail purchases when he was governor.

Senator Hitchcock, meanwhile, voted consistently in Washington for bills that promised supports for farmers, agricultural credits and crop insurance—all parts of the president's New Deal. Usually, Hitchcock was South Dakota's only senator voting that way. Although Senator Bulow,

of course, was a Democrat, he grew increasingly wary of Roosevelt's New Deal programs. In 1937, Hitchcock and Bulow were aligned in their thinking about Roosevelt's Judiciary Reorganization attempt (more often called the Supreme Court packing bill). They worked together to defeat what they considered a dangerous overreach by the president into another branch of government.

Berry decided to enter the Democratic primary in the spring of 1938, challenging the man he appointed to the Senate. He stressed his past success in winning South Dakotans federal aid and his relationship with Roosevelt, and he claimed that more state citizens supported the New Deal than opposed it.

He defeated Hitchcock in the primary, prompting the *New York Times* to speculate about a possible "cowboy Senator." The *Times* quoted Berry saying, "I'll lick any Republican they put in the race against me" and described him for its national readership as "a picturesque figure. He is a rancher and looks and acts the part; hence the 'cowboy Governor' nickname. His speech is salty and his campaign addresses are a compound of good humor, homely common sense, anecdotes and cajolery." The *Times* article went on to report that Berry's general election opponent would be "Chan Gurney, Yankton oil man."[151] Gurney possessed one of the state's most recognized names. His family founded an early South Dakota radio station, the far-reaching WNAX of Yankton, and he had delivered news and sports himself. He was also involved in his family's long-established Gurney Seed Company, and the oil the *New York Times* referred to was a popular Gurney gasoline brand franchised to service stations across South Dakota—and promoted over WNAX. Also central to Gurney's image was his army service in Europe during World War I. As aggressive fascism throughout the world alarmed Americans in the late 1930s, Gurney advocated for strong national defense.[152]

Berry and Gurney, both accomplished businessmen who loved politics, stood in sharp contrast in other ways. Berry, of course, remained as solidly a West River cowboy as ever, while Gurney came across as East River, a midwesterner. Gurney was seventeen years younger than Berry.

During the campaign, Berry quoted advice his father had long ago offered: "Little ships should stay close to shore, while bigger ships can venture more," referring to business people who too quickly consider themselves major capitalists and are lured into debt. Did Chan Gurney, with his many business interests, fit that mindset? Berry didn't say so, but he described his own business as mortgage free with "plenty of hay and cattle, sons and daughters who know their business and attend to it—what more could a man ask?"

One editor noted that Berry had "developed into one of the leading platform speakers of the state and his quips have never been sharper than in this drive." Berry didn't intend to be a rubber stamp for Roosevelt, but he left the door open to be "a rubber stamp for the people of South Dakota." On the stump, he endorsed soil and water conservation—vital to South Dakota's Dust Bowl recovery—better conditions for students and teachers, reworking aspects of Roosevelt's farm policy that weren't satisfactory and a federal old-age pension. He linked the pension to job creation in South Dakota, noting that when older people retired, their jobs could be filled by a younger workforce. The Senate race of 1938 was perhaps Berry's best campaign performance, with clearly stated goals, presidential support and a record as governor that looked better and better with a little passage of time.[153]

But it wasn't enough. Chan Gurney won in November. The defeat felt crushing—two losses in statewide elections in two years could certainly end a political career. Berry made no public comment when the result became clear. He went home to the ranch and wasn't heard from until December, when he told the Associated Press he wished South Dakotans a Merry Christmas and a prosperous 1939. "I did not issue any statement after the election," he said, "so I thought I would take this opportunity to thank the 133,064 friends who so loyally supported me."[154]

Also going down to defeat in 1938 were the Gold Dust Twins. Oscar Fosheim had captured the Democratic nomination for governor, while Emil Loriks was endorsed for U.S. House of Representatives. Historians would later describe the 1938 South Dakota election as one of the very first anywhere to see Democrats accused of associating with communists. Fosheim and Loriks's leadership within the South Dakota Farmers Union appeared to be a key to the accusations. Elsewhere, socialists and communists had sometimes supported farm associations, and the *Sioux Falls Argus Leader* reasoned that "[c]andidates who endorse policies that are communistic should not be surprised when they, in turn, receive the blessings of Communists." For decades after 1938, calling political opponents (usually Democrats) "soft on Communism" would be a South Dakota autumn ritual as predictable as hunting pheasants.[155]

For Berry, there wouldn't be another chance to try for the U.S. Senate for four years. If he did so, it would likely mean challenging another Democrat, Senator Bulow, in the 1942 primary.

Bulow, to Berry's increasing dismay, seemed as consistently opposed to the Roosevelt administration as any Republican. He didn't like the New Deal, of course, and as the president worked to bolster national defense, Bulow

Berry with granddaughters, Nancy and Judy Phipps, and hounds. *Berry family.*

labeled it "irresponsible spending." He said, "In my judgment, this country is in more danger of going to pieces by reasons of the continuation of an unbalanced budget than it is in danger of defeat by all the navies of the world." Senator Bulow was an isolationist who, on the Senate floor in 1939, said it was the business of Italians to live under fascism if they so desired and predicted that Germans would eventually "revolt and throw off the yoke of Hitlerism. Anyway, that is their business—not ours."[156]

Senator Gurney generally opposed Roosevelt's domestic programs but was as supportive of his defense initiatives as any Senate member.

Tom Berry, meanwhile, stepped up to chair South Dakota's Democratic State Central Committee, endorsed President Roosevelt's 1940 run for an unprecedented third term and supported Webster attorney Lewis Bicknell's bid for South Dakota governor. Roosevelt won nationally but couldn't claim South Dakota's votes. Bicknell lost to Republican Harlan Bushfield, yet another governor with his eyes on an eventual Senate seat.

The world changed when Japan drew the United States into World War II, bombing Pearl Harbor, Hawaii, on December 7, 1941. Suddenly, Senator Bulow's isolationist views seemed dangerously naïve. A movement took root among state Democrats to "draft" Tom Berry to accept their party's 1942 senate nomination. In January, an Associated Press reporter reached Berry, at his ranch, by phone. "What are you going to do now?" the reporter asked.

"Get a bite of dinner and then go out with the boys to separate some more bulls," Berry replied.

"No, no, we're talking politics."

"Well, that's the political activity on this ranch today," Berry said.[157]

In fact, he was eager to run. The "draft Berry" movement didn't advance far. Most party members wanted to hear what others would say during primary campaigns. Democrat Edward Prchal from Burke, former legislator and in 1942 a member of the board of regents that oversaw state higher education institutions, announced his candidacy. Of Bulow, Prchal went so far as to assert that "thousands of our boys will be killed who would not have been called upon to make that sacrifice if we had the airplanes and warships such as we will have in a year or more. Their blood will be upon this willful group, including Senator Bulow, who thought they knew so much more than President Roosevelt."[158]

Berry, as the press worded it, threw his cowboy hat into the ring not long after his phone conversation about sorting bulls. "We must win the war, we must win the peace, and we must win the battle for re-adjustment during the reconstruction period that will follow the peace treaty," Berry said. If South Dakotans weren't exactly sure what he meant by winning the peace, Berry would fully elaborate shortly.

Tom Berry Says:--
WIN THIS WAR QUICKLY

I am for winning this war as quickly as possible.
I am for bringing the soldiers back home at the earliest possible moment.
I am for restoring peace and all its blessings just as fast as it can be done.

South Dakota Wants Peace

The people of South Dakota abhor war. I abhor war. I believe that any man who represents this state in the United States Senate should be against war and for a lasting peace.

I believe the people of this state want a world where peace cannot be broken by dictators or aggressors.

I believe the people of South Dakota want this time that we should win the war and also WIN THE PEACE.

Berry campaign ad, 1942 U.S. Senate race. *Berry family.*

Prchal charged that both Bulow and Berry were too old and referred to his own age as "a quarter century younger than Bulow." Prchal added, "Before Bulow could serve out his term, he will be 80 years old and Tom Berry is no spring chicken. He would be past 70 years old. That's too old. Their minds are back in the horse and buggy days."[159]

Bulow said he voted as an isolationist because most South Dakotans had considered themselves isolationists. Berry called Bulow's statement "a libel on the patriotism of the people of South Dakota, and it's cowardly of Bulow to try now to blame them for his record."[160]

Senator Bulow turned the campaign personal, charging that Berry was leasing twenty-seven thousand acres of reservation grazing land, with just pennies per acre going into the pockets of Lakota people.[161] If South Dakota Democrats were disappointed that Roosevelt didn't carry South Dakota in 1940, Bulow said, they had only to consider the president's state campaign director, Tom Berry. Sounding very East River, he criticized Berry for wasting federal soil conservation dollars on perennially arid, nonproductive "bad lands" out West River. The long Berry-Bulow alliance and friendship lay shattered.

Just before the primary election, Berry drove to Yankton to deliver a speech over Chan Gurney's WNAX. Twice he spoke directly to parents of men and women in military service. "If I win this nomination and the election in the fall as your Senator, you need have no fear that I will not devote all my time and effort and energy toward bringing about a complete victory as quickly as possible," he said. "I know you do not want your boys flying planes that can't hold their own with Jap planes. I know you don't want them defending themselves with shovels as some of the gallant Marines were forced to do at Wake Island….We can produce the best planes, the best ships, the best artillery, the best tanks, and the best rifles in the world." Helping South Dakota farmers be as productive as possible for foreign markets was vitally important, too, because "Hitler is now trying to wipe out whole nations by starvation."

He didn't mention Senator Bulow specifically, but he criticized isolationist politicians in general for their "short-sighted opposition to the President's plans for preparedness." He described moving steers from his ranch to market, of putting "a cowboy with a bunch of saddle horses ahead of them to lead the way. If he happens to move ahead so far the steers can't see him, they start milling, and then he must wait until they catch up with him. That's the way it has been with the President. He had to wait until the voice of a united people, after Pearl Harbor, enabled him to move ahead in spite of the

obstruction. They [former isolationists] now say they are licking the billy-hell out of the Japs."[162]

Days later, Berry had his primary victory and began preparing for his fall campaign against Republican Senate nominee Harlan Bushfield, in the final year of his second term as governor. A well-spoken attorney from Miller, Bushfield had worked hard to deny Berry a third term as governor as the Republican State Committee chairman in 1936. As governor, he stressed economic efficiency, disliked government services that competed with private enterprise and had been—Berry knew—as much of an isolationist before Pearl Harbor as Bulow. In addition to campaigning for his own cause, Berry also stumped for Lewis Bicknell, running a second time for governor.

Berry spoke again of his longtime commitment to federal pensions for older Americans except, perhaps, "for a luxurious old-age pension for lame-duck Congressmen who have been receiving a salary of $10,000 a year."[163]

While Berry was "for winning this war as quickly as possible," no one could call him a warmonger, a term sometimes thrown at Roosevelt before Pearl Harbor. "War is just wholesale murder," read campaign literature Berry signed. "It must be abolished throughout the world, so persons and peoples can know they will be safe from bombs and bullets."[164]

That's what he meant by "winning the peace": securing a military victory and then revisiting the concept of a League of Nations that would intervene in international disputes and outlaw war. It was what President Woodrow Wilson worked for after World War I, Berry reminded South Dakotans, but in 1919, "six United States Senators defeated the treaty of peace our soldiers had won in the other World War, leaving the door open for this second world war. So the babies of 1919 are fighting today, in another world war. Vote November 3 so that the babies of today will not be required to go forth to war in another 20 years."[165]

Berry questioned why Bushfield made no response to his "winning the peace" idea. In fact, it would become clear later that Bushfield didn't believe in the concept. He defeated Berry easily on November 3 and then went to Washington and could be counted on to support spending for the war. But he voted against the United Nations. It was hard for isolationists (and Bulow was correct in saying there were many in South Dakota) to see how war could be outlawed without the United States becoming embroiled in foreign disputes as a peacekeeper. By the fall of 1942, it had become clear that the United States had emerged as a major international power.

Bushfield was not successful in blocking the establishment of the United Nations, and he did not complete his six-year term. He died of a stroke with

a few months left to serve in 1948, and his wife, Vera, was appointed briefly to the Senate seat Berry wanted so much.[166]

Berry's 1942 defeat ended his attempts to win public office, and in fact, he would never see a South Dakota Democrat win the governorship or a U.S. Senate seat in his lifetime. Shortly after the election, President Roosevelt appointed Berry as a director of the federal Farm Credit Administration based in Omaha. He wouldn't reside in Omaha but would drive in from the ranch for directors' meetings. George Philip, the old cowboy and United States attorney for South Dakota, wrote to say, "Your selection to the big board in Omaha gave me great pleasure, because I know of no one who should be able to give better service in that capacity. In a life devoted to the production of human food, you have made an outstanding success....I envy your set-up and your opportunity to work in close contact with your two fine sons. I think few men are given the high privilege of going down the western slope in such a grand arrangement."[167]

Farm Credit Administration financing was quiet work. Yet there's insight into Berry's thinking about bureaucratic expansion of the program, thanks to his guest column the *Mitchell Daily Republic* published in July 1945. Berry wrote the piece in the style of Will Rogers. "I could see," he noted, "from seven to twelve more people at $12,500 per year with more deputies, secretaries and stenographers. I kinder got to thinkin' that someone would have to pay them. I figgered it would be the farmer and rancher who borrow the money. Up interest a cent or so. You know, folks, there are just a lot of people who are living off the Government, and Lordy how they like it."

In the same column, he criticized President Harry Truman, in office just three months after Roosevelt's death that spring, for proposing salary increases for war plant workers and members of Congress and for seeking former president Hoover's advice on feeding hungry populations as World War II wound down. "I remember," Berry quipped, "what Herbert fed us when he was food administrator during the last war, and what he didn't feed us when he was President."[168]

At one point, someone noticed that Berry was wearing his hair a bit longer and joked that maybe he fancied himself primarily a writer now, as he had adopted a long-haired poet look. Not so, Berry replied. His barber in Belvidere was displaying a Republican poster, so he was boycotting the place for a while.

Tom and Rena made time to be active grandparents. Ralph "Shorty" Jones, Faye's son, was born the last year of his grandfather's governorship. Growing up, Shorty experienced the Berry dogs, Tom's engaging stories (it seemed even the hounds became alert and listened when stories started flowing) and family gatherings on holidays. "Easter was the big one because he'd spend the whole day hiding eggs, over and over, I don't know how many times," Shorty recalled. "He loved competition, so he made hunting eggs a competition for the grandkids." There were eleven grandchildren, all living on area ranches.

Later, when Shorty was twelve or so, Berry would drop by for a visit and tell his grandson that he had visited Shorty's cousin Keith (Paul's son), who was hauling two wagon loads of hay a day to cattle. "It was competition again," Shorty said with a laugh. "He liked to see us compete, to inspire us to do our best. And he probably visited Keith and told him how I was hauling lots of hay or doing some other work very well."[169]

After six years with the Farm Credit Administration, Berry announced his resignation in December 1947. "This is my New Year's Resolution," he told the *Mitchell Daily Republic*. "I'm quitting the farm credit board. I have resolved to wear no bridle that I can't take off myself."

His health was suddenly a concern as he approached his seventieth birthday. Heart trouble slowed him down. Berry pledged loyalty to South Dakota Democrats in the 1948 elections. "That's about all I can give now on account of my health," he told a reporter. He added that both Democratic and Republican representation were needed for healthy governance, and he didn't like the Republican stronghold on elected officials in Pierre and on representatives South Dakotans sent to Washington. He claimed no insight into direction Democrats might take at their state and national conventions in 1948, remarking that the party organization wasn't letting members "know anything about what they have in mind, if they have anything…but I do owe my loyalty to the Democrats of South Dakota and the nation. They have given me everything that I asked for that was within their power."[170]

Far removed from the political conventions of 1948, Berry had big plans for the South Dakota Stock Growers annual gathering that June in Hot Springs. All cowboys who had ridden in the great 1902 roundup were invited to a reunion, running concurrently with the stock growers' convention. Forty men showed up to recall adventures on the plains forty-six years earlier. The *Rapid City Daily Journal* reported that cowboys "were so enthusiastic about the gathering and the chance to meet fellow cowpunchers from West River

country that plans were made immediately to form an organization to perpetuate the first cowboy reunion ever held in the state."[171]

The men decided to meet annually, authorized writer Bert Hall to produce a book-length account of their stories and elected officers. By a unanimous vote, Berry became president of the 1902 Cowboys (also known as the Last Roundup Club). At the end of that first reunion, Berry established a memorial tradition, reciting the names of cowboys who had "gone over the hill."

In 1950, the name Berry again appeared on South Dakota ballots. Mobridge newspaper publisher E.Y. Berry, a Republican, ran for the U.S. House of Representatives, where he would serve for twenty years. In this, his first House campaign, he guessed that voters would wonder about a family connection to the former Democratic governor. Sure enough, the question came up when the campaign trail took him to Rapid City. "We're not related," E.Y. Berry said.

"Good," the questioner responded. "I think that other Berry was the worst governor this state ever had." The room exploded in laughter. The questioner was none other than Tom Berry himself.

Reunion of 1902 cowboys with their president, Tom Berry, standing at left. *Berry family.*

Berry paid tribute to a fellow 1902 cowboy with a ceremonial bandana. *Berry family.*

By the time of the encounter with E.Y. Berry, Tom and Rena had been living in Rapid City for a year. They bought a house near pretty Canyon Lake and returned to the ranch regularly for branding, shipping steers and family celebrations. They quickly decided they wanted more land in Rapid City because they were engaged in a new animal production venture. On the ranch, Tom appreciated greyhounds, able to drive off or kill predators. In Rapid City, he bred and trained the dogs for a sports fad that seized the Black Hills: parimutuel greyhound racing at a track near Rapid City. The Berrys began building a house outside Rapid City, close to the track.

They moved there in 1951, but their time together in the house was brief. On October 30, 1951, Berry drove downtown to see his lawyer, Tom Eastman. There was a deed to sign. Eastman was out that afternoon, his secretary explained, but she had the deed. She handed it to Berry, who said, "I'll sign anything once." Then he collapsed, dead of a massive heart attack.[172]

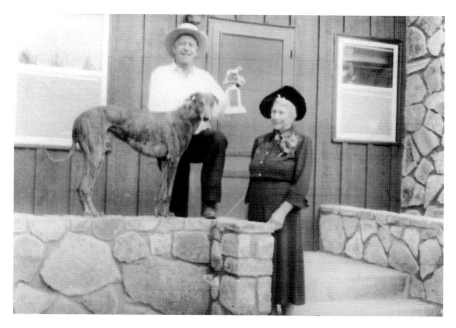

Tom and Rena with a prize-winning greyhound. *Berry family.*

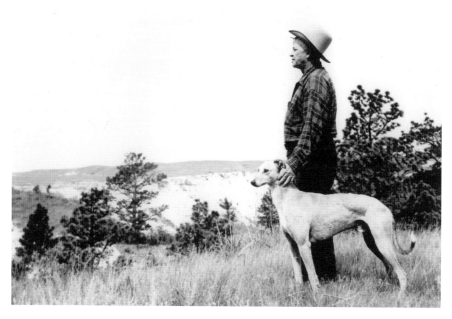

Berry in a pensive mood (or at least posing that way) with a favorite hound. *Berry family.*

Among the first to make public comment was Governor Sigurd Anderson, informed of Berry's death after making a speech in Sioux Falls. He extended sympathy to the Berry family and said, "Mr. Berry was governor of the state during the trying times of the Dust Bowl and was faced with many problems that called for utmost administrative capacity."[173] Berry's passing was national news. The *New York Times* wrote that he "was distinguished by a careless mop of hair and an infectious grin. He said his early education was gained from 'sittin' in the shadow of a cow pony.' The wit that won him a political following was spontaneous. Campaigning on the Democratic ticket in a rock-ribbed Republican state, he became known for his homespun quips and people everywhere repeated his stories."[174]

TIME magazine remembered "one of the last of the costumed, showman politicians, he shaded his cat eyes and weather-beaten face under a white sombrero."[175]

The South Dakota press placed more emphasis on what the state's residents could never forget: the Dust Bowl and Berry's efforts to pull them through it. "The news wires said today that Tom Berry is dead," reported Pierre's *Capital Journal*. "That isn't true. Tom Berry will never die so long as there is a South Dakotan breathing who breathed the atmosphere of dust and despair which pervaded South Dakota in 1932."

The *Aberdeen American News* reminded readers that criticism of Berry's leadership had sometimes been harsh in the 1930s. "But in recent years more praise than criticism has been heard about the manner in which he met the problem of his time—the problem being food and shelter for people and livestock and the solvency of the state. The *Aberdeen American News* this fall asked for readers' nominations for the governor they believed had done the best job in the past 20 years. More of them named Gov. Tom Berry than any other."

The *Rapid City Journal* also noted that nearly fifteen years after leaving the governorship, many South Dakotans recalled Berry as the state's best leader ever. The paper also praised his contributions to the cattle industry—"the main spring of West River economy."

In Sioux Falls, an *Argus Leader* editorial noted that "when Tom Berry completed his two terms as governor in 1937, the *Argus Leader* paid him a high tribute for his courage, his devotion to basic ideals and his able service. It repeats that statement now. He served South Dakota extremely well in what may well be regarded as the most difficult economic period in the state's history."

Berry, recalled the *Mitchell Daily Republic*, "was looked upon as one of Franklin D. Roosevelt's favorites among the nation's governors; certainly

he won many saving federal appropriations....Tom Berry was a man of ready wit and fellowship, a man who will be surely missed by a host of staunch friends."

Three days after Berry's passing, family and friends and state officials gathered at Belvidere's Presbyterian church. Reverends C.M. Weirauch and Condon Terry officiated over the funeral service. Burial at the Belvidere cemetery was a Masonic rite.

Rena lived to see another Democrat serve as the state's governor in 1959, when Ralph Herseth was inaugurated. She was present in 1960 when Tom's portrait, painted by Yankton artist Margaret Matson McIntosh, was unveiled in the state capitol. He was depicted wearing a Stetson and his trademark grin. Another McIntosh portrait was unveiled as part of the same ceremony—that of the late William Bulow.[176] Rena was still living in 1962 when her husband was inducted into the National Cowboy Hall of Fame in Oklahoma City.

She died the next year after an illness, just weeks after George McGovern became the first South Dakota Democrat in twenty years to take a seat in the United States Senate. "I always enjoyed her friendly encouragement during my visits with her," McGovern wrote the Berrys. Rena was eighty-four. In addition to her service as South Dakota's first lady, the press recalled Rena as a teacher and a builder of a successful ranch business, noting that "even after the Berrys retired and moved to Rapid City to live, they were interested in the cattle business."[177]

Eighty years after he last held public office, Tom Berry's name could still trigger lively political discussion—even debate—in South Dakota. Can there be a more appropriate legacy for a politician? There are plenty who say that Berry's actions as governor saved their family, farm or entire community. At the same time, there are those descended from South Dakotans who survived the 1930s who insist that no savior appeared on the scene, that their family got through hard times by working to exhaustion daily despite hunger and dust burning their eyes. Still others criticize Berry for opening the door to federal intrusion into South Dakota life. In general, ask a South Dakotan knowledgeable about twentieth-century American history his or her opinion of Franklin Roosevelt, and you'll probably know his or her opinion of Tom Berry.

The capitol building in Pierre has been beautifully preserved so that it looks much the same as when Berry served. But a better place to come

Above: Governor Berry advocated for water conservation in many forms, including stock dams found across cattle country. *Ryan Phillips.*

Below: Cowboy country that Tom Berry loved. *Ryan Phillips.*

to understand the cowboy governor's love for South Dakota is the state's southwest, moving west from the Missouri River on Highways 18 and 44, through Gregory and across lands where Lamoreaux cattle once roamed. The wheat fields that drove Tom and Rena away in search of perennial cattle country have given way to crops of corn and beans now, and the land bears Tom Berry trademarks of shelter belts and stock dams.

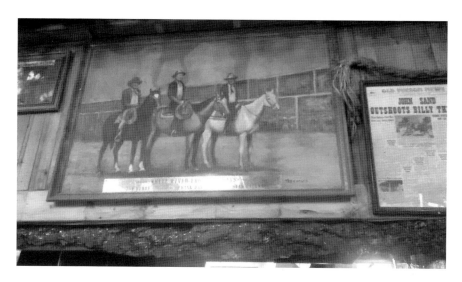

Artwork depicting Tom Berry as saddle bronc judge, Frank Day's Bar, Dallas, South Dakota. *Author's photo.*

Just west of Gregory in tiny Dallas, Berry's friend Frank Day built a saloon, and over the bar hangs a painting by Ted Corneil that is something of a contrast to Berry's official portrait at the capitol. It depicts him on horseback judging the 1922 Frontier Days rodeo. The journey continues through the Rosebud Reservation, where Berry would still recognize family names and a vibrant horse culture but also poverty he described to the Roosevelt administration. The governor had his squabbles with higher education, but there can be no doubt that he would see tremendous value in a tribal university developed on the Rosebud long after his death. Further on lies the town of White River, where Frontier Days still plays out annually. This countryside was home, and here Berry family cattle still graze.

NOTES

Chapter 1

1. *Mellette County, 1911–1961*, 285.
2. *TIME*, "National Affairs" (November 13, 1933): 12.
3. Warren Morrell, "Thru the Hills," column, publication and date unknown, Berry family papers.
4. Hunhoff, *South Dakota's Best Stories*, 92.
5. *Mellette County, 1911–1961*, 174–76.
6. Theodore Roosevelt, "In the Cattle Country," *Century Magazine* (February 1888).
7. *Sturgis Tribune*, Special Stockgrowers Edition, "Boyhood Dream of Becoming a Cattleman Led Berry to Hall of Fame," May 23, 1962, Section 4, 3–7.
8. *Rapid City Daily Journal*, "Berry Funeral Rites Friday," October 31, 1951, 1 and 4.
9. Schell, *History of South Dakota*, 327–28.
10. *Sturgis Tribune*, Special Stockgrowers Edition.
11. Lang, *Ranching with Roosevelt*, 177–78.
12. Blasingame, *Dakota Cowboy*, 24.
13. Theodore Roosevelt, "The Round-Up," *Century Magazine* (April 1888).
14. *Sturgis Tribune*, Special Stockgrowers Edition, May 1962.
15. John Simpson, "President Harry Truman Visits Gregory in 1911," *Gregory Times-Advocate*, January 8, 2014, 1.

16. *Mellette County, 1911–1961*, 174–76.
17. Frank Day, taped interviews with Baxter Berry, 1972.
18. Nell Phipps (Berry), "Tom Berrys, Mellette County Pioneers," collected in Reutter, *Mellette County Memories*, 13–14.
19. *Sturgis Tribune*, Special Stockgrowers Edition, May 1962.
20. Charlotte Hubbard Prescott, Central Press correspondent, source and date unknown, clipping in Berry family papers.
21. *Mellette County, 1911–1961*, 174.
22. Ibid., 282–86.

Chapter 2

23. Fite, *Peter Norbeck, Prairie Statesman*, 39–100.
24. John Miller, "Our Cowboy Governor," *South Dakota Magazine* (November 1986): 6–11.
25. *Biographical Directory of the South Dakota Legislature*, 91.
26. Miller, "Our Cowboy Governor," 8.
27. United Press dispatches, author's possession.
28. Schell, *History of South Dakota*, 275.
29. Ibid., 277.
30. Fite, *Peter Norbeck, Prairie Statesman*, 80–85.
31. Pressler, *U.S. Senators from the Prairie*, 98.
32. Ibid.
33. Lee and Williams, *Last Grass Frontier*, 453–56.
34. Dillon Haug, "Scovel Johnson," Papers of the Twenty-Third Annual West River History Conference (2015), 137–39.
35. *TIME*, "National Affairs—The Presidency" (August 8, 1927): 7.
36. *TIME*, "National Affairs—The Presidency" (July 25, 1927): 9.
37. *TIME*, "Political Notes" (August 1, 1927): 9.
38. *Mellette County, 1911–1961*, 175.
39. Fite, *Peter Norbeck, Prairie Statesman*, 168–83.
40. Will Chamberlain, feature, *Pierre Capital Journal*, April 16, 1932.
41. *Mellette County Pioneer*, "Tom Berry of Mellette County Has Lassoed the Democratic Endorsement for Governor," May 1932, 1.
42. Joseph Ryan, Tom Berry chapter in Oyos, *Over a Century of Leadership*, 127–31.
43. Press clipping, Berry family papers, source unknown.
44. *Aberdeen American News*, "Tom Berry, Jovial Candidate, Is in Aberdeen," date unknown, clipping in Berry family papers.

45. Tom Berry letter to *Yankton Press*, published and undated, Berry family papers.
46. Berry family papers.
47. *Huron Daily Plainsman*, "Berry Says Would Fight for Slash in All State Salaries," undated, Berry family papers.
48. S.L. Martin, letter to *Argus Leader* editor, filed in Berry family papers.
49. *Arlington Sun*, "As a Republican Sees Tom Berry," date unknown, clipping in Berry family papers.
50. Associated Press, "Berry—M'Cullough in Auto Crash," October 29, 1932.
51. *Sioux City Journal*, date unknown, Berry family papers.
52. Associated Press, "Berry Expresses Thanks to State," November 10, 1932.

Chapter 3

53. *Pierre Capital Journal*, "First Lady to Lead Grand March," date unknown, Berry family papers.
54. Associated Press, "Berry Bits," January 5, 1932.
55. Ibid.
56. *Commercial West*, "S.D. Saves Honor and Credit," April 8, 1933, Berry family papers.
57. *Denver Post*, "South Dakota Pioneer Spirit Is Revived," December 31, 1932, Berry family papers.
58. *TIME*, "Milestones" (November 12, 1951): 88.
59. Philip and Draine, *Cowboy Life*, 1–8.
60. Associated Press, "Senate Office Building a Nice Sheep Shed, Berry," June 7, 1933.
61. Associated Press, "Says He Does Not Give a Damn About Political Future," date unknown, Berry family papers.
62. Associated Press, "Goes to Berry After 91 to 10 Ballot in House," August 5, 1933.
63. Associated Press, "Berry Commended for Beer for Relief," date unknown, Berry family papers.
64. Associated Press, "Roosevelt to Take Sanitarium Request Personally," date unknown, Berry family papers.
65. Associated Press, "Roosevelt Promises Aid for S.D. Farmers," September 8, 1933.

66. Civilian Conservation Corps Museum of South Dakota, Hill City, South Dakota.

67. Gies, *Franklin D. Roosevelt*, 137.

68. *TIME*, "Agriculture" (October 30, 1933): 12.

69. Schell, *History of South Dakota*, 287.

70. *TIME* (November 6, 1933): 18.

71. *TIME*, "Agriculture" (November 13, 1933): 13.

72. Ibid.

73. Ibid.

74. *TIME*, "National Affairs—Agriculture" (November 20, 1933): 16.

75. Unpublished account by Berry family member, Berry family papers.

76. Associated Press, "Berry Requests in Washington Draws Official's Respect," November 22, 1933.

77. "'Republican' Dog Nips Democratic Governor in Leg," source unknown, press clipping in Berry family papers.

78. Associated Press, "Berry Shows Teeth, Plans to Back Law," February 22, 1934.

79. Lorna B. Herseth, memoirs (N.p.: self-published, 1994), Berry family papers.

80. Associated Press, "Indians to Get 25,000 Cattle," June 28, 1934.

81. Associated Press, "Cattle Shipping Total Now 48,000," June 23, 1934.

82. Lee and Williams, *Last Grass Frontier*, 283.

83. Hall, *Reflections of the Badlands*, 237–41.

84. Albert Stevens, "Man's Farthest Aloft," *National Geographic* (January 1936): 94.

85. Rena Berry's speech dedicating the Explorer gondola, Berry family papers.

86. Associated Press, "Berry Gets Flag from Strato Trip," September 18, 1934.

87. Associated Press, "Berry Opens Campaign at Miller, Orient," date unknown, Berry family papers.

88. Associated Press, "Bulow Laughs at Whispering Campaign," date unknown, Berry family papers.

89. Associated Press, "Hitler Tactics Used by Demos, Alseth Charges," October 17, 1934.

90. Associated Press, "Berry Gets Another Letter from Roosevelt," October 15, 1934.

91. Clement Valandra, letter to *Sioux Falls Argus Leader*, Berry family papers.

92. *Pierre Capital Journal*, "Berry Sweeps State Ticket to Victory," November 7, 1934, 1.

93. George Eastman, "S.D. Man Visits Hollywood with Rogers, Governor," originally published in a San Diego newspaper (unidentified), Berry family papers.

94. O'Brien, *Will Rogers*, 156.

95. Ibid., 234.

96. *Los Angeles Times*, "Will Rogers Remarks," November 9, 1932, 1.

97. Eastman, "S.D. Man Visits Hollywood."

98. Associated Press, "Rogers Declines Invitation from Governor Berry," January 8, 1935.

99. Associated Press, "Highlights Taken from Berry's Speech," January 8, 1942.

100. Associated Press, "Governor Berry Signs New S.D. Liquor Control Law," undated, Berry family papers.

101. Ryan, Tom Berry chapter in Oyos, *Over a Century of Leadership*, 127–31.

102. Williams, *Emil Loriks*, 45–52.

103. Friggens, *Gold and Grass*, 75–85.

104. Williams, *Emil Loriks*, 48.

105. *Pierre Capital Journal*, "Berry Highlights," January 8, 1935.

106. Williams, *Emil Loriks*, 50.

107. Gerald Wolff and Joseph Cash, "South Dakotans Remember the Great Depression," *South Dakota History Quarterly* (Summer 1989): 251–55.

108. Ibid.

109. Associated Press, "Strike in Morrell Plant Settled After Berry Directed Martial Law 2nd Time," March 12, 1935.

110. Lynwood Oyos, "Labor's House Divided: The Morrell Strike of 1935–37," *South Dakota History Journal* (Spring 1987): 67–88.

111. Associated Press, "Berry Wisecracks Way Into Hearts of U.S. Officials," April 16, 1935.

112. Associated Press, "Berry, His Requests Approved in Washington, to Start Home," April, 1935.

113. Associated Press, "Berry 'Won't Run Against Senator Bulow,'" undated, Berry family papers.

114. Associated Press, "Berry Bars Newsman from Press Meet," undated, Berry family papers.

115. *Los Angeles Times*, "Will Rogers' Last Remarks," August 17, 1935, 1.

116. Ibid., "Rogers—Post Arctic Death Crash Related," 1.

117. Associated Press, "Berry Feels Loss in Death of Rogers," August 16, 1935.

118. United Press, "Tom Berry of S.D. Seen as Successor in Rogers Role," August 23, 1935.

119. Tom Berry columns, Berry family papers.

120. Stevens, "Man's Farthest Aloft," 80.

121. Reese, *1938 South Dakota Guide*, foreword.

122. Gilfillan, *Sheep*, 231.

123. Lisle Reese, "The South Dakota Federal Writers Project: Memories of a State Director," *South Dakota State Historical Society Quarterly* (Fall 1993): 197–243.

124. Berry's nationally syndicated column, January 1936, South Dakota State Historical Society Archives, Pierre, South Dakota.

125. John Bailey, *Aberdeen American News*, "Tom Berry Runs State but on Roundup Takes Orders from Son," May 1936.

126. Associated Press, "Berry Cheers Addresses of Demo Keynoters," June 25, 1936.

127. Associated Press, "Hitchcock Asserts Delegates Pleased with New Platform," date unknown, Berry family papers.

128. Berry's seconding speech, Berry family papers.

129. Berry's original note for calling for vote by acclamation, Berry family papers.

130. *Time*, "National Affairs—The Presidency" (July 6, 1936): 9–10.

131. Associated Press, "Offers to Debate Gov. Tom Berry Mounted on Pony," undated, Berry family papers.

132. Fite, *Mount Rushmore*, 171.

133. Press clipping, "I'm Glad to Come Back!" source unknown, Berry family papers.

134. Associated Press, "Largest Crowd in History of City Greets President on Stop at Aberdeen, SD," August 28, 1936.

135. Press clipping, "F.D.R. Greets Redfield People from His Train," source unknown, Berry family papers.

136. Smith, *Carving of Mount Rushmore*, 311–12.

137. Fite, *Mount Rushmore*, 132.

138. Smith, *Carving of Mount Rushmore*, 311–12.

139. Ibid.

140. Oyos, *Over a Century of Leadership*, 132–37.

141. *Webster Journal*, "Tom Berry—Draws a Happy Crowd—They Gave Him Cheers Both Long and Loud," November 1936, Berry family papers.

142. Cartoon collected in South Dakota State Historical Society Archives.

143. Associated Press, "Much-Ballyhooed Berry Dam Found to Be Several Miles Above Ranch" (includes full text of Commercial Club letter), undated, Berry family papers.

144. Fite, *Peter Norbeck, Prairie Statesman*, 205–8.

145. Pressler, *U.S. Senators from the Prairie*, 107–10.

146. Kilian, *Tales of Old Dakota*, 133–37.

147. Associated Press, "Text of Berry's Address Before State Legislature," undated, Berry family papers.

148. *TIME*, "Milestones" (November 12, 1951): 88.

Chapter 4

149. *Watertown Public Opinion*, "Berry in Washington Spotlight," August 28, 1937 (included Chamberlain newspaper observation).

150. Newspaper clipping, "Tom Berry Wants Job, Too, Would Like to Be Mayor of Sioux Falls," date unknown, Berry family papers.

151. *New York Times*, "Cowboy Senatorship Now Tom Berry's Aim," May 8, 1938, 71.

152. Pressler, *U.S. Senators from the Prairie*, 114–16.

153. John Baily, column, *Aberdeen American News*, Berry family papers.

154. Associated Press, "Berry Bids Supporters Merry X-Mas," undated, Berry family papers.

155. Thompson, *New South Dakota History*, 208–9.

156. Pressler, *U.S. Senators from the Prairie*, 97–106.

157. Associated Press, "Berry Won't Give Comment," January 22, 1942.

158. Associated Press, "Blood of U.S. Soldiers on Bulow's Hands, Prchal Says," undated, Berry family papers.

159. Associated Press, "Prchal Says Berry, Bulow Are Too Old," date unknown, Berry family papers.

160. Associated Press, "Bulow Practices Hit by Berry," April 25, 1942.

161. Associated Press, "Bulow Says Berry Backs Roosevelt Only for Votes," date unknown, Berry family papers.

162. Text of Berry's WNAX speech, Berry family papers.

163. Berry press statement, February 1942, Berry family papers.

164. Campaign literature, Berry family papers.

165. Newspaper ad, publication and date unknown, Berry family papers.

166. Pressler, *U.S. Senators from the Prairie*, 124–30.

167. George Philip letter, Berry family papers.

168. *Mitchell Daily Republic*, guest column, July 31, 1945.

169. Shorty Jones, interview with author, November 29, 2016.

170. Associated Press, "Berry Would Like to See S.D. Demos Active," February 28, 1945.

171. *Rapid City Journal*, "50 Cowhands Reminisce on Last Roundup," June 4, 1948, Berry family papers.

172. *Rapid City Daily Journal*, "Our Cowboy Governor Will Be Deeply Missed," undated, Berry family papers.

173. *Mitchell Daily Republic*, "Tom Berry, SD's Colorful 'Cowboy' Governor in Depression Era, Dies at 72," October 31, 1951, 1.

174. *New York Times*, "Ex-Gov. Tom Berry of South Dakota," October 31, 1951, 71.

175. *TIME*, "Milestones" (November 12, 1951): 88.

176. *Rapid City Daily Journal*, photo, August 5, 1960, Berry family papers.

177. McGovern letter, Berry family papers.

BIBLIOGRAPHY

Books

Biographical Directory of the South Dakota Legislature. Pierre: South Dakota Legislative Research Council, 1989.

Blasingame, Ike. *Dakota Cowboy*. Lincoln: Bison Books/University of Nebraska Press, 1964.

Brennan, Stephen, ed. *The Best Cowboy Stories Ever Told*. New York: Skyhorse Publishing, 2011.

Fite, Gilbert. *Mount Rushmore*. Norman: University of Oklahoma Press, 1952.

———. *Peter Norbeck, Prairie Statesman*. Pierre: South Dakota State Historical Society Press, 2005.

Friggens, Paul. *Gold and Grass: The Black Hills Story*. Boulder, CO: Pruett Publishing Company, 1983.

Gies, Joseph. *Franklin D. Roosevelt: Portrait of a President*. New York: Doubleday and Company, 1971.

Gilfillan, Archer. *Sheep*. Boston: Little, Brown, and Company, 1929.

Hall, Phillip. *Reflections of the Badlands*. Vermillion: University of South Dakota Press, 1993.

Hoover, Herbert T., and Larry Zimmerman, eds. *South Dakota Leaders*. Vermillion: University of South Dakota Press, 1989.

Hunhoff, Bernie, ed. *South Dakota's Best Stories*. Yankton, SD: Middle Border Books, 2004.

Kilian, Tom. *Tales of Old Dakota*. Sioux Falls, SD: Pine Hill Press, 2004.

Lang, Lincoln. *Ranching with Roosevelt*. Philadelphia, PA: J.B. Lippencott and Company, 1926.

Lee, Bob, and Dick Williams. *Last Grass Frontier*. Sturgis, SD: Black Hills Publishers, 1964.

Lee, Wayne. *Scotty Philip: The Man Who Saved the Buffalo*. Caldwell, ID: Caxton Printers, 1975.

Mellette County Centennial Committee. *Mellette County, 1911–1961*. White River, SD: self-published, 1961.

Mellette County, 1911–1961. White River, SD: Mellette County Centennial Committee, 1961.

O'Brien, P.J. *Will Rogers: Ambassador of Good Will, Prince of Wit and Wisdom*. Philadelphia, PA: John C. Company, 1935.

Oyos, Linwood, ed. *Over a Century of Leadership*. Sioux Falls, SD: Center for Western Studies, 1987.

Philip, George, and Cathie Draine. *Cowboy Life: The Letters of George Philip*. Pierre: South Dakota State Historical Society, 2007.

Pressler, Larry. *U.S. Senators from the Prairie*. Vermillion: University of South Dakota Press, 1982.

Reese, Lisle. *1938 South Dakota Guide*. St. Paul, MN: Minnesota Historical Society Press, 2006. Republished WPA book.

Reutter, Paul, and Winnifred Reutter. *Mellette County Memories*. White River, SD: self-published, 1961.

Schell, Herbert. *History of South Dakota*. Rev. ed. Lincoln: University of Nebraska Press, 1968.

Smith, Rex Allen. *The Carving of Mount Rushmore*. New York: Abbeville Press Publishers, 1985.

Thompson, Harry, ed. *A New South Dakota History*. Sioux Falls, SD: Center for Western Studies, 2005.

Williams, Elizabeth. *Emil Loriks: Builder of a New Economic Order*. Sioux Falls, SD: Center for Western Studies, 1987.

National Periodicals

Denver Post
Los Angeles Times
National Geographic
New York Times
Time

Key South Dakota Periodicals

Aberdeen American News
Gregory Times-Advocate
Mitchell Daily Republic
Pierre Capital Journal
Rapid City Journal
Sioux Falls Argus Leader
South Dakota History
South Dakota Magazine
Webster Journal

INDEX

ABOUT THE AUTHOR

Paul Higbee is a Governor's History Award (South Dakota) recipient, best known for features and columns appearing in *South Dakota Magazine* since 1986. He also taught graduate-level local history for teachers through Technology and Innovation in Education (TIE) and was lead writer for South Dakota Public TV's Emmy Award–winning *Dakota Pathways*, a history series for children. Paul holds degrees from Black Hills State University and the University of Notre Dame. He and his wife, Janet, reside in the Black Hills.